The
BEARTOOTH HIGHWAY

The BEARTOOTH HIGHWAY

A HISTORY OF AMERICA'S MOST BEAUTIFUL DRIVE

JON AXLINE

THE
History
PRESS

Published by The History Press
Charleston, SC
www.historypress.net

Copyright © 2016 by Jon Axline
All rights reserved

Cover, top: Flash's Photography, Red Lodge.

First published 2016

Manufactured in the United States

ISBN 978.1.46713.579.5

Library of Congress Control Number: 2016935732

For Janene Caywood—colleague and, most importantly, friend.

CONTENTS

Acknowledgements 9

Introduction 11

1. America's Best Drive: The Beartooth All-American Road 15

What's in a Name 18

2. Before the Beartooth Highway 25

3. A Wonderful Piece of Engineering: The Black and
White Trail 33

Doc Siegfriedt and the Cradle of Mankind 34

4. A Necessary and Feasible Road: The National Park
Approaches Act 39

The Father of the Beartooth Highway: O.H.P. Shelley 41

The National Parks Approaches Act of 1931 51

5. The Greatest Piece of Road in America: Building the
Beartooth Highway 53

Points of Reference 61

Opening the Beartooth Highway 71

6. The Trials and Tribulations of Jack McNutt and Guy Pyle 75

7. An Excellent Road Chiseled Out of the Mountainside:
Completing and Maintaining the Beartooth Highway 83

8. The All-American Road and the Rebirth of Red Lodge
and Cooke City 99

The Princeton Geology Field Camp 106

CONTENTS

Notes 109
Bibliography 113
Index 117
About the Author 121

ACKNOWLEDGEMENTS

I recall reading an axiom once that stated, perhaps facetiously, that history doesn't repeat itself; historians merely repeat one another. To some degree that's true, since every new history book relies on the research done by others—along with, ideally, new research to make the book interesting. This modest book is no exception. I relied heavily on past publications and new information from the Yellowstone National Park archives in Gardiner, Montana. Some of this you may have seen before, but I bet there is some information in here you haven't yet seen. This history doesn't tell the whole story of the highway—that would have far exceeded my publisher-imposed word limit—but it's a good start.

In 2014, the National Park Service, along with the blessings of the Montana and Wyoming Departments of Transportation, listed the Beartooth Highway on the National Register of Historic Places, a well-deserved honor that was long in coming. The National Register nomination provides the most comprehensive history of the Beartooth Highway. For that, I thank the efforts of my colleagues at Historical Research Associates in Missoula, Montana, and especially Janene Caywood. Yellowstone National Park archaeologist Elaine Hale shepherded the nomination through federal and state government bureaucracies and was there to receive a certificate for her patience at the Montana State Historic Preservation Office's biennial awards ceremony in 2015.

People who provided valuable assistance for this book include Debbi Brown, Dana Wahlquist and Samantha Long at the Carbon County

ACKNOWLEDGEMENTS

Historical Society in Red Lodge; the staff at the Montana Historical Society's Research Center; and, as ever, my co-workers at the Montana Department of Transportation. I'd also like to recognize Mark and Ellen Baumler, John Boughton, Kate Hampton, my much-valued associates on the Montana State Historic Preservation Review Board and my contact at The History Press, Artie Crisp. Finally, I couldn't do any of this without the love and support of my family, Lisa, Kate and Kira.

INTRODUCTION

After many years of argument, debate and inactivity, the Beartooth Highway was finally listed in the National Register of Historic Places in May 2014. Work on the nomination began in the early 2000s, when the Forest Service hired the Missoula firm of Historical Research Associates to research and write the nomination for the highway. The process took over a decade to complete, and the result was, in my opinion, the most comprehensive history of the origins, construction and significance of one of the United States' most famous and scenic highways. The National Register nomination describes the highway and firmly places it in context of the time it was constructed. The Beartooth Highway, as many realized, was a Great Depression–era "make work" project to put unemployed men to work and, in the process, not only regenerate the economies of Red Lodge and Cooke City but also provide a new, and extremely scenic, access to Yellowstone National Park. Consequently, the history of the Beartooth Highway is tied inextricably with the history of Red Lodge, Cooke City and the park. The National Register nomination filled in a gap in our understanding of the region and the highway and why it is so significant not only to south-central Montana but also to the history of the state during that turbulent decade.

Perhaps not surprising, the discussions between the National Park Service and the Montana and Wyoming Departments of Transportation reflected many of the issues that have involved the highway since it was constructed in the 1930s. While the park service supported the development

of the nomination, debate arose at the DOTs about the impact the National Register listing would have on the agencies. Initially, both DOTs opposed the nomination. I sat in on some of the discussions, and the dialogue centered on the maintenance of the highway. Wyoming believes—and not without reason—that the highway benefits Montana and Yellowstone National Park, not its state. The National Park Service would like to rid itself of the responsibility of the highway between the northeast entrance and the Montana state line at Line Creek. The Montana Department of Transportation will continue to maintain the fifteen miles of highway south of Red Lodge but was worried how the National Register nomination might impact its ongoing programs to take care of the route and keep it safe for travelers. In the end, however, those issues were resolved, and the agencies' support for the nomination resulted in the National Register listing in 2014. It was interesting for a Montana historian to experience issues that have been ongoing since 1931.

Through all of this, though, is the Beartooth Highway, an All-American Road that has been praised for the amazing scenic vistas visible from it and as an engineering marvel. This is the story of the origins of the highway; the political wrangling that occurred in Montana and Washington, D.C.,

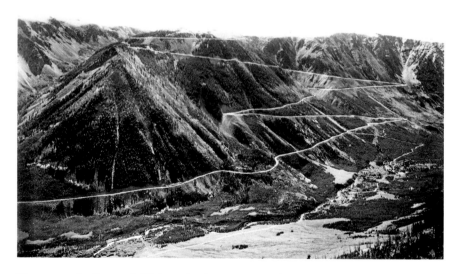

The spectacular Beartooth Highway has been a magnet for tourists and photographers since its completion in 1936. *Carbon County Historical Society.*

to get it authorized and funded; its construction; and what has happened with it afterward. It's a great story and not indicative of the history of other highways in Montana. Although it faced some of the same issues as other highways, the Beartooth Highway seems to be, in many ways, a fusion of the history of road construction in Montana during the 1930s. No highway, with the exception of the Going to the Sun Highway in Glacier National Park, has been so richly described, however. So sit back and enjoy this trip over the Top of the World, the Beartooth Highway.

AMERICA'S BEST DRIVE

THE BEARTOOTH ALL-AMERICAN ROAD

In the Beartooth mountains is found all the old majestic beauty of the Swiss Alps, yet there is something different, too, something wild and wondrous about this rugged, richly wooded country that one surveys from the country's highest and most novel highway—11,000 feet high.
—Helena Independent, *June 23, 1936*

Montana is a state filled with scenic highways. No matter the western one-third or the eastern two-thirds of the state, motorists are sure to be treated to highways that pass through some of the most beautiful panoramas in the lower forty-eight states. But despite that, travelogues mostly concentrate on the two drives in Montana that are the most spectacular: the Going to the Sun Highway in Glacier National Park and the Beartooth Highway between Red Lodge and the northeast entrance to Yellowstone National Park. Both highways were constructed within just a few years of each other, and both traverse some of the most rugged topography in the northern Rocky Mountains. Some might say that neither road should have been built or that it would be impossible to build roads like them today. Stories of the construction of the highways are epic and include extraordinary engineering techniques, sometimes death-defying construction practices on the part of the contractors and completed roads and vistas that continue to boggle the ability of motorists to describe. While the story of the Going to the Sun Highway is well known, the story of the origins, construction and maintenance of the Beartooth Highway

is less so. Descriptions of the Beartooth abound, as do accounts by those who have experienced it. But the story of where it came from, how it was built, the men who built it and issues about who is responsible for it and the difficulty of maintaining it are less known. This book will answer at least some of those questions and, hopefully, add to the experience of those driving the Beartooth Highway.

The year 2016 will mark the eightieth anniversary of the official completion of arguably the most scenic road in the lower forty-eight states: the Beartooth Highway. The Federal Highway Administration designated the route an All-American Road in 2002. The sixty-eight-mile highway spans the "top of the world" between Red Lodge and Cooke City in south-central Montana and provides access to Yellowstone National Park. The highway is an engineering marvel and is a magnificent combination of awe-inspiring scenery coupled with occasional abject terror as one navigates the switchbacks and looks down over the side of the mountain to the valley below. For me, the highway has been a white-knuckle drive with overwhelming vistas that are well worth the anxiety the drive causes

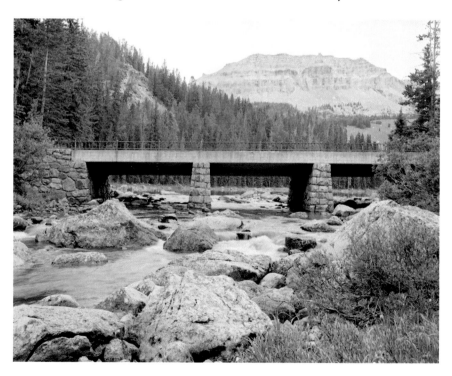

One of the many rustic bridges on the Beartooth Highway. *National Park Service, HAER.*

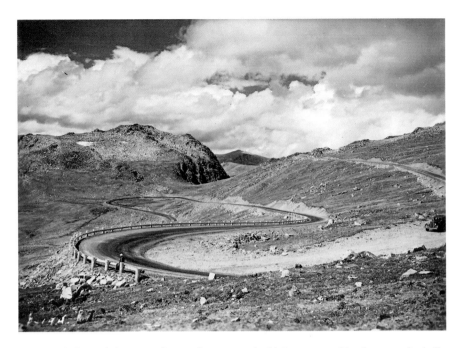

Deadman's Curve is just one of many features on the highway named by the men who built the road in the 1930s. *Carbon County Historical Society.*

me. Historically, the Beartooth Highway is one of the best-documented roadways in the region, but much of that history has been locked away in federal archives and hasn't been available to the general public. The origin and construction of the Beartooth reads more like a good novel than a dry transportation history.

The Beartooth Highway officially begins about nine miles south of Red Lodge, the seat of Carbon County in south-central Montana, on U.S. Highway 212. From the base of the mountains, the highway begins a steep but steady climb up the side of the Rock Creek Canyon. The twenty-three-foot-wide roadway passes through a series of tightly curled switchbacks. The curves have colorful names like Mae West, Deadman's, Primal and Frozen Man's—names bestowed on each of them by the men who built the highway in the early 1930s. There isn't much of a shoulder on the road, and motorists are separated from the abyss by only a thin ribbon of steel guardrail. It's a long way down, but the breathtaking landscape viewed from any vantage point on the road quickly makes the motorist forget any danger of driving over the edge of the highway.

WHAT'S IN A NAME?

By 1934, there was still no official name for the highway. The National Park Service called it the Cooke City Road, while the *Billings Gazette* promoted the road as the Beartooth Highway. Red Lodge businessmen and promoters called it the Red Lodge–Cooke City Highway—at least that's how it appeared in the *Red Lodge Picket* and the *Carbon County News*. In 1960, the Montana State Advertising Department (then a part of the Montana State Highway Commission) solicited possible new names for the highway. Among the potential names submitted to the commission's advertising director, Dorris Stalker, were Highway to the Clouds, Highway to the Skies and Highway to the Heavens.

The highway reaches the top of the Beartooth Plateau at an altitude of 10,947 feet, a little over 1,000 feet above the tree line. From that vantage point, words fail to adequately describe the panorama that spreads out in all directions. A newspaper writer observed in 1936 that "every hundred yards reveal a new vista, a new wonderland that fairly begs for the camera to set down what the eye can hardly credit."[1] The highway crosses the border into Wyoming at the top of the Beartooth Plateau.

The Beartooth Highway then winds its way across the top of the plateau, past alpine lakes, scrub vegetation and glaciated landscape, to where the road begins the long descent through Wyoming and Montana to the northeast entrance of Yellowstone National Park. The road passes through coniferous forests and crosses over streams and the Clark's Fork of the Yellowstone River over some of the most interesting bridges in the region. As the highway descends the plateau, motorists are also treated to an abundance of wildlife, including deer, elk, mountain goats and an occasional bear or wolf. The scenery is no less spectacular with magnificent views of Index and Pilot Peaks as the road nears the old mining camp of Cooke City that, because of the highway, transformed itself into a tourist stop. The highway then passes through the post-highway construction community of Silver Gate to the northeast entrance to Yellowstone National Park. The total length of the highway is 68.7 miles.

Most Montana highways, including the Beartooth, follow routes established long ago by Native Americans. Civil War general Phil Sheridan and a 120-man escort traveled over a portion of the route on a visit to Yellowstone National Park in 1881. Five years later, the Rocky Fork Coal

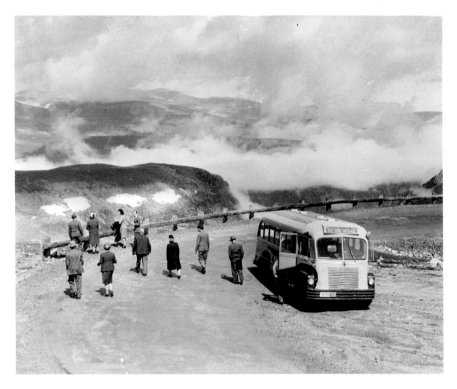

For years, the Red Lodge Chamber of Commerce provided guided tours of the highway in yellow buses. *Carbon County Historical Society.*

Company established a coal mine on Rock Creek at the foot of the Beartooth Mountains, which led to the establishment of Red Lodge. The presence of gold mines in the mountains near Cooke City caused Red Lodge boosters to advocate the construction of a railroad over the mountains between the two mining camps in the late nineteenth century. It was not until 1919, however, that the Montana State Highway Commission and Carbon County cooperated in an attempt to build a highway across the plateau. Called the Black and White Trail by its Montana and Wyoming promoters, it worked its way up the mountainside by way of thirteen switchbacks, nearly reaching Line Creek at the top of the Beartooth Plateau in 1921. Changes in federal priorities for highway funds caused the highway commission to abandon the unfinished road by 1924. But the dream to build a highway across the Beartooth Plateau didn't die with the abandonment of the trail.

The Beartooth Highway is very much a product of the 1930s and the Great Depression. Debate about the construction of the road transpired in the halls of Congress for much of the Roaring Twenties. Few disputed

the need for the road, but uncertainties about how to pay for it and who exactly would benefit from the road persisted in Washington, D.C., through much of the decade. The road's greatest advocates in Congress were *Carbon County News* publisher O.H.P. Shelley, longtime Carbon County booster Dr. J.C.F. Siegfriedt and Montana's eastern district congressman, Scott Leavitt. The National Park Service also pushed for a road between Cooke City and Red Lodge, but for different reasons. Mining in the mountains northeast of Cooke City meant that trucks carrying ore had to pass through roads

A tourist's paradise, the Beartooth Highway provides access to some of the most rugged country in the lower forty-eight states. *Carbon County Historical Society.*

on the north side of the park to reach the railroad station at Gardiner, Montana. A new approach road from Red Lodge would remove that traffic and, importantly, create a new entrance for tourists to enter the park. The 1929 stock market crash and the following economic depression provided the incentive that finally tipped the scales in favor of the passage of the National Parks Approaches Act of January 31, 1931.

Building the Beartooth Highway required scores of workers and provided a much-needed economic boost to Red Lodge, Cooke City and Yellowstone National Park. Economic hardship had a direct bearing on President Herbert Hoover's decision to sign the legislation that created the Beartooth Highway in 1931. The Great Depression fueled the expansion of the country's interstate transportation network and triggered the golden age of automobile tourism in the United States. Road projects, like this one, required a lot of workers, and there was no shortage of unemployed men desperately in need of work during the Depression. Indeed, one of the requirements of the legislation authorizing the construction of the road was that the contractors hire workers locally and adhere to federally established wage rates. In Montana, the Beartooth Highway was just a small part of the more than four thousand miles of highway improved by the federal Bureau of Public Roads and the Montana Highway Department during the 1930s. While most of the

Since the 1870s, Pilot and Index Peaks near Cooke City have been important landmarks in the area. *Author's collection.*

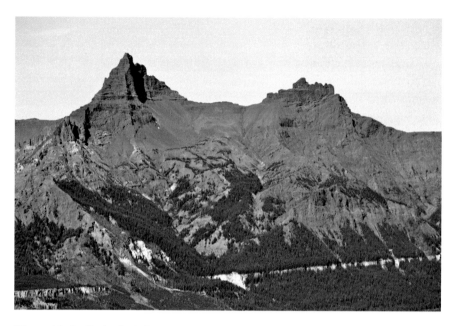

Pilot and Index Peaks, Park County, Wyoming, Absaroka Range. *Photo by Mike Cline (CC BY-SA 4.0).*

work building the highway was done with power equipment, the highway could not have been completed without the men wielding picks, shovels and pry bars.

The Beartooth Highway's status as one of America's most scenic roads flourished after World War II, when automobile tourism once again gripped the country during a new national economic boom. Red Lodge and Cooke City benefitted from the vast numbers of tourists who stopped in their communities to visit local attractions, like the See 'Em Alive Zoo in Red Lodge; stay in one of the new motels; eat at local restaurants; shop for souvenirs; and fuel up at local gas stations. One theme that runs through all of the documentation of the highway is the impact of weather on the road. Opened for only a few months during the late spring, summer and early fall, businesses in Red Lodge and Cooke City depended on the road for their survival during that short time each year.

The weather and changes in highway design and traffic standards have resulted in significant work being done to the Beartooth Highway since 1960, including new bridges, the abandonment of original road alignments, slide repairs, replacement guardrails and the occasional repaving of the roadway. Mother Nature, however, is always quick to

Sometimes you just had to get out of the car to really appreciate the power of the highway. *Warner F. Clapp photo. Carbon County Historical Society.*

remind engineers, maintenance workers and motorists who is really in charge. In 2005, a major earth slide on the highway closed the road during the critical months the highway is open. The Beartooth Highway is narrow, winding and sometimes frightening, but the spectacular views have continued to thrill motorists for over eighty years.

In 1979, famed CBS correspondent Charles Kuralt proclaimed the Beartooth Highway "the most beautiful drive in America." The highway is currently maintained by the Montana Department of Transportation and the National Park Service. Listed in the National Register of Historic Places, the spectacular Beartooth Highway is a testimonial to the vision of those

The way the highway is designed gives motorists the impression that the road is draped over the landscape. *Carbon County Historical Society.*

who fought for its construction and a tribute to those who pushed for and built this road "perched jauntily on canyon walls and the brink of some nature's most awesome precipices."[2]

BEFORE THE BEARTOOTH HIGHWAY

Cooke City has been waiting years for reasonable transportation connections to the outside world so that her promising ore deposits may be profitably mined. She's no blushing maiden, but this highway is the answer to her prayers.
—Montana Highway Department Historical Marker, 1936

The Beartooth Mountains contain some of the oldest exposed rocks on Earth and provide a unique window into the history of our planet. About 55.0 million years ago, this massive block of metamorphic basement rock pushed its way upward nearly two miles along steep faults that extend deep down into the earth. The exposed rock consists of coarse-grained gray and pink granites, gneisses and schists that formed about 3.3 billion years ago, when older sedimentary and volcanic rocks were heated and recrystallized deep in the earth at extremely high temperatures. The plateau contains the oldest exposed rocks in Montana, and they are among the oldest known on the planet. Most motorists on the highway, perhaps unknowingly, pass by 3.3 billion years of Earth's history.

During the ice ages, about 100,000 years ago, the Beartooths collected enough snow for glaciers to form and cover most of the plateau to a depth of several thousand feet. The spreading glaciers wore down the plateau's upper surface to leave the distinctively rounded rock outcrops, along with hundreds of lakes, ponds and depressions. The glaciated rock on top of the plateau posed a serious obstacle for the builders of the highway, so much so that it caused the contractor to fail to meet his deadline for completion of his part

Small lakes and ponds dot the landscape adjacent to the highway and are the last remnants of ancient glaciers. *Yellowstone National Park Archives.*

of the project. The glaciers flowed down old stream valleys, leaving them deepened and straightened, with vertical canyon walls and jagged peaks. The summit of the Beartooth plateau is alpine tundra well above the tree line in altitude.

Although humans have lived in the vicinity of these mountains for at least 11,500 years, it wasn't until Captain William Clark saw the mountains during his journey down the Yellowstone River in July 1806 that we got the first written description of the range. Clark described the mountains as "rocky rugid [*sic*] and on them are great quantities of snow."[3] The fur trappers and traders who followed Clark undoubtedly knew about the Beartooth range, but the extent of their penetration into the mountains is unknown. They left behind few descriptions of the mountain range.

The federal government's creation of Yellowstone National Park in 1872 attracted a small number of tourists into the region in the late nineteenth century, including famed Civil War general Philip Sheridan. In August 1881, Sheridan and his escort navigated what would, half a century later, become the Wyoming section of the Beartooth Highway. His report of the journey frequently comments on the abundance of wildlife and the "enormous glaciers" of the Beartooth Mountains. As the party neared Cooke City, Sheridan, not particularly known for his glibness or romanticism, wrote that "standing up against the sky, were Pilot Knob and Index Peak, the great

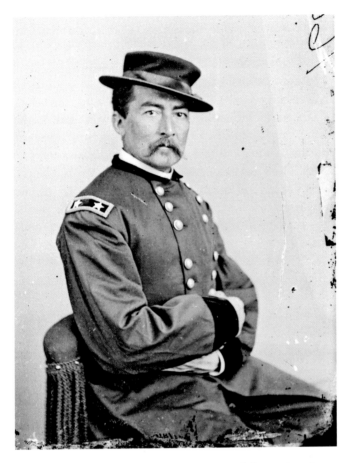

In 1881, Civil War general Philip Sheridan traveled a portion of what would become the Beartooth Highway fifty-five years later. *Library of Congress.*

landmarks of the Rocky Mountains. After feasting our eyes on this view, unparalleled in grandeur and extent, we continued our march through grassy parks until we reach the edge of the valley of Indian Creek."[4]

In many ways, Cooke City must have seemed a bit odd nestled in such an untamed landscape. The tiny mining camp consisted of one habitable house and twenty cabins "in all stages of construction" and a primitive smelter to process the ores extracted from the surrounding mountains. It is not known how many miners were in the camp during Sheridan's visit, but most of the men only casually worked their claims because they were illegally located within the Crow Indian Reservation. Some of the miners had been in the area for eight or nine years "waiting for some

Congressional action to permit them to make their fortunes." It would be another decade before the men could legally work their mining claims. Cooke City was finally removed from the reservation in 1892, when the tribe ceded its land between the current reservation boundaries and the Boulder River to the west to the federal government.[5]

Sheridan, like many other Euro-Americans, trespassed on the territory of the Crow Indians. The Beartooth Mountains and the Rock Creek Valley on the north side of the mountains were part of the aboriginal territory of the Apsaalooke (Crow) Indians. Arapooish, an Apsaalooke chief, described Crow Country as "a good country because the Great Spirit had put it in exactly the right place." The Mountain Crow division of the Apsaalooke established themselves in northern Wyoming and south-central Montana over five hundred years ago, or possibly earlier. The Mountain Crow ranged as far east as the Powder River and as far west as the great bend of the Yellowstone River. The tribe came to depend on the great availability of game and edible plants in the region.

The 1851 Fort Laramie Treaty established Crow territory as encompassing all lands south of the Musselshell River between the headwaters of the Yellowstone River to the west, the headwaters of the Powder River to the east and the main ridge of the Wind River Mountains in Wyoming to the south. After the discovery of gold in southwestern Montana in the early 1860s, continuous pressure by miners and cattlemen caused several reductions to the original Crow Indian Reservation boundaries. The second Fort Laramie Treaty in 1868 further reduced Crow territory by removing all lands in Wyoming and north of the Yellowstone River, making the eastern boundary the divide between the Big Horn and Rosebud Rivers; it restricted the nomadic Crow to approximately eight million acres. An agreement ratified by Congress in 1882 eliminated all Crow lands west of the Boulder River. In this same agreement, the Crow ceded a wide strip of land that extended from the Boulder to the Clark's Fork of the Yellowstone, encompassing the Clark's Fork River and Rock Creek Valleys. The 1882 agreement allowed for the development of coal deposits located within the ceded strip. Pressure placed on the Crow Indians by Cooke City and Red Lodge mining, railroad and cattle interests resulted in Congress removing the area east of the Boulder River to the present Crow Indian Reservation's western boundary in 1892.

James "Yankee Jim" George discovered extensive coal deposits in the upper Rock Creek drainage in 1866. Its remoteness, lack of a market for the product and location within the boundaries of the Crow Reservation delayed its

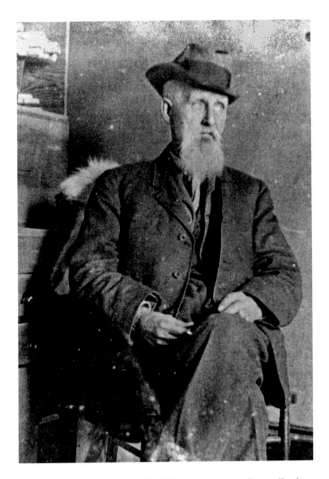

Prospector James "Yankee Jim" George is generally credited with discovering rich coal deposits in the Red Lodge area in 1866. *Yellowstone Gateway Museum, Livingston.*

exploitation for over two decades. In 1887, a group of Bozeman and Helena businessmen formed the Rocky Fork Coal Company to mine the fossil fuel at the site of a tiny stage stop settlement on the Meteetsee Trail called Red Lodge. By late 1887, the company's owners had made an arrangement with the Northern Pacific Railway to construct a branch line from Laurel forty-four miles south to Red Lodge and the coal mines in 1889. The Rocky Fork & Cooke City Railway sparked a growth of coal mining in the region that was expanded when the Crows formally ceded the region from their reservation in 1892. The railroad and, later, the Anaconda Copper Mining Company used most of the coal mined at Red Lodge.

Red Lodge originated as a stage stop on the Meteetsee Trail between Billings on the Yellowstone River and Fort Washakie in Wyoming in 1884. The opening of the Rocky Fork Coal Company mines on the east and west benches bracketing Rock Creek and the arrival of the railroad in 1889 sparked a boom in the mining camp. The railroad brought hundreds of immigrants and their families to the remote community to mine coal, thereby creating a working-class, cosmopolitan town rich in its ethnic diversity. By 1900, Red Lodge boasted a population of Americans, English, Irish, Germans, Italians, Slavs and Finns, the largest ethnic group in the community. The different groups lived in separate neighborhoods, but the men worked together underground in the coal mines. The demand for Red Lodge coal steadily increased from 1900 until 1919, when labor strikes, coupled with an economic depression, caused a significant decline in the demand for Red Lodge coal. Beginning in 1923, the Northern Pacific Railway obtained much of its coal from strip mines in southeastern Montana and the Anaconda Company in Butte, and Anaconda became reliant on electricity produced by Montana Power Company dams on the Missouri River.

The Rocky Fork Coal Company's West Side Mine closed in 1924. The East Side Mine shut down six years later, in 1930. Red Lodge, however, remained an important rail shipping point and trading center for area

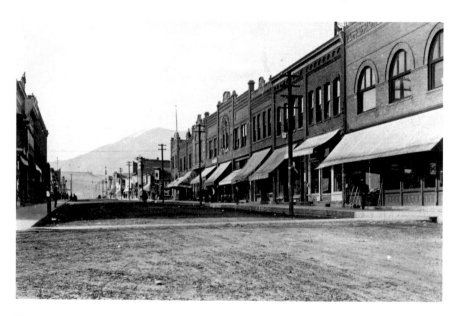

The lack of traffic and pedestrians on Red Lodge's main street hinted at the economic woes that plagued the community in the late 1920s. *Carbon County Historical Society.*

farmers and ranchers and for the nearby coal mines in the Bear Creek drainage. Red Lodge was, literally, located at the end of the road at the base of the Beartooth Mountains with no real prospects for its future.

Like Red Lodge, Cooke City originated as a mining camp on the Crow Reservation in 1870. Miners filtered into the remote area just northeast of recently established Yellowstone National Park and extracted gold, silver and other minerals from the Beartooth range in the New World Mining District. Heavy snow and the lack of a good all-weather road to ship the minerals to processing plants in Montana and elsewhere proved a chronic problem for the development of the mines. Indeed, for at least six months of the year, snow rendered Cooke City the most isolated settlement in the region or, perhaps, the entire American West. Beginning in the late nineteenth century, optimistic promoters ballyhooed the impending arrival of a railroad connection, but the remoteness of the area, the rugged mountains and the heavy snow precluded any real attempt to build a railroad to Cooke City.

By the early twentieth century, a few companies, like Gottwerth "Doc" Tanzer's Western Smelting and Power Company, were operating mines and mills northeast of Cooke City in the New World Mining District, but their remoteness and lack of transportation facilities mostly doomed the operations after a few years. After World War I, Yellowstone National Park officials allowed the mining companies to transport ore across the northern part of the park to Gardiner, but the park service restricted the trucks to just a few hours per day during tourist season. By the 1920s, National Park Service administrators had actively sought a way to end the truck traffic in the park. The growing importance of the automobile would provide the connection that the railroads could not for Cooke City.

The Beartooth Mountains were a barrier to the development of a railroad and, at least in the beginning, a good auto route. The lack of a reliable transportation system doomed Cooke City and prevented the large-scale development of the rich mines of the New World Mining District northeast of the camp. The elusive permanency of mining, even of coal, also weighed heavily on businessmen and promoters in Red Lodge on the north side of the range. Beginning after World War I, coal mining declined in Montana based on the electrification of the Anaconda Copper Mining Company's operations, the increasing movement away from coal for domestic purposes and the Northern Pacific Railway's switch from Red Lodge coal to the cheaper and easier-accessed coal fields near Colstrip. Some, like Bearcreek and Red Lodge physician J.C.F. Siegfriedt, undoubtedly saw the handwriting on the wall and began to aggressively seek new sources of

Cooke City originated as a mining camp with an uncertain future in the 1870s within the Crow Indian Reservation. *MHS Photograph Archives, Helena, 946-569.*

revenue for the coal camps. Always a little bit ahead of his time, Siegfriedt saw the connection between the automobile and economic prosperity and, beginning in 1915, began to pursue that avenue for the benefit of Carbon County and Cooke City.

A WONDERFUL PIECE OF ENGINEERING

THE BLACK AND WHITE TRAIL

Dr. J.C.F. Siegfriedt, president of the Black and White Trail Association, of Red Lodge, Mont., will start a campaign to secure funds to build a road from Red Lodge to Cooke City by popular subscriptions. It is thought that Federal aid can also be secured. The new road will make Red Lodge a Yellowstone Park entrance and also provide an outlet for ore from the mines to Cooke City.
—The Road-Maker, Excavator and Grader: A Monthly Journal Devoted to the Development, Construction and Maintenance of the Highway, *January 1920*

In the early years of the twentieth century, new roads were sometimes as much a product of local promoters as they were of engineers. By World War I, Montana was crisscrossed by nearly sixty-eight thousand miles of county roads, some of which bore the designation of State Highway. Yet as automobile technology improved and roads were reconstructed to better accommodate the horseless carriage, some Montanans looked for ways to draw visitors to the Treasure State primarily to enhance local economies. Community boosters were important to the process, and much of Montana's early tourism industry was dependent on them. Of those, one man particularly stood out: John Charles Friedrich "Doc" Siegfriedt.

Born in Iowa in 1879, Doc Siegfriedt graduated from the University of Illinois's College of Physicians and Surgeons in Chicago in 1902. That year, he came to Montana and worked for a while as a physician in the town of Wibaux before moving to the booming coal mining camp of Bearcreek in

Carbon County in 1906 to tend to the miners and their families. During his twenty-four-year tenure there, Siegfriedt served five terms as the city's mayor and became a tireless advocate for the county. A man of many interests, all of which involved the economic development of Carbon County in some fashion, he was a well-regarded amateur paleontologist and geologist. An inveterate "joiner," he belonged to every civic and fraternal organization that would have him in Bearcreek and in nearby Red Lodge. To paraphrase Alice Roosevelt's comment about her father, Teddy: at weddings, Siegfriedt wanted to be the bride, and at funerals, the corpse. He was the center of attention wherever he went.

DOC SIEGFRIEDT AND THE CRADLE OF MANKIND

Siegfriedt was a man of many interests, most of which were connected somehow to the marketing of Red Lodge and Carbon County. In addition to his medical practice, his fervent boosterism and the endless meetings he attended, Siegfriedt was also a respected amateur geologist and paleontologist. His home near the unique and varied geology of the Beartooth Mountains and the nearby coal mines at Bearcreek provided excellent specimens to further fuel his interests. In 1924, miners at the Eagle Coal Mine near Bearcreek found a fossilized molar that Siegfriedt thought might have belonged to a human ancestor. No one could accuse Siegfriedt of being a shrinking violet. He proclaimed the tooth evidence that human progenitors had lived at the foot of the Beartooth Mountains for at least a million years in what was a Garden of Eden for prehistoric man.

Whether the physician actually believed his claim is unknown, but it didn't stop him from using the fossil to, of course, promote Carbon County. The tooth generated some debate for a time among paleontologists from the American Museum of Natural History and Princeton University. It didn't take much time, however, before paleontologists determined that the tooth was not human and, in fact, had come from a Paleocene ungulate, called a *condylarth*, that lived in the area some sixty million years ago. Today, Doc Siegfriedt is known primarily for his contributions to the development of Carbon County and his theory about the Beartooth Mountains being a primeval Cradle of Mankind.

In 1915, Siegfriedt formed the Black and White Trail Association to build a road across the Beartooth Mountains from Bearcreek to Cooke City. The proposed scenic road had a dual purpose: to provide access to Cooke City and Yellowstone National Park and to attract tourists and outdoorsmen to the area's recreational attractions. By the spring of 1919, Doc Siegfriedt had raised enough money by public subscription to build nearly two miles of the road from Bearcreek to the base of nearby Mount Maurice southeast of Red Lodge. Siegfriedt's and Carbon County's determination to build the road compelled the Montana State Highway Commission to fund a project to build nearly three miles of the Black and White Trail later that year. The highway commission had just begun funding road projects with the state's share of the million dollars allotted to it by the 1916 Federal Aid Road Act. In the case of the Black and White Trail, Carbon County was responsible for providing the state's match for the federal money. The state highway commission designed the road, surveyed the route and provided a project manager on-site when construction was underway. Photographs of the survey crew taken in 1919 indicate that fishing the Beartooth's many trout-rich streams was a favorite off-hour activity for the men.

In May 1919, the highway commission and Carbon County awarded a contract to Albert Carlson of Columbus to construct 2.7 miles of the Black and White Trail for $31,699, under the direction of a civil engineer named T.O. "Red" Thatcher. Work on the project began that month, and the road to the top of Line Creek Plateau was completed by the middle of August. The *Red Lodge Picket-Journal* reported that by early July, the work crews had built thirteen switchbacks up the side of Mount Maurice. The switchbacks climbed eight hundred feet on a 2 to 10 percent grade through a narrow canyon. Federal Bureau of Public Roads (BPR) engineers and state highway commissioner Dan Curran were impressed by the work and

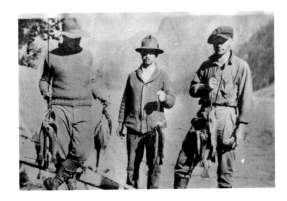

When not establishing the route for the Black and White Trail, surveyors fished the many creeks and lakes in the Beartooths.
Carbon County Historical Society.

"Red" Thatcher was the Montana State Highway Commission's resident engineer on the Black and White Trail project between 1919 and 1921. *Carbon County Historical Society.*

pronounced the road ready for automobile traffic. Beartooth National Forest supervisor R.T. Ferguson was even more gushing about the road and, especially, its biggest supporter:

> *It was through the untiring efforts of Dr. Siegfriedt…who although faced with an almost unheard of task, that of building an automobile road up the side of a 9,000 foot mountain whose almost precipitous slopes are cut and gashed by numerous gulches, set his shoulder to the wheel and did not cease pushing until he had obtained his goal and the success of the project was assured.[6]*

Mainly because of Siegfriedt's efforts to build the road, he was often referred to in local newspapers as "the Father of the Black and White Trail."

Doc Siegfriedt hoped the completion of nearly five miles of road would enable him to raise more money to finish the Black and White Trail over the Beartooth range to Cooke City. By 1920, he had moved his medical practice to nearby Red Lodge and made plans to change the route of the trail, with the northern terminus at Red Lodge instead of at Bearcreek. Siegfriedt raised enough money to survey the route from Mount Maurice over the Line Creek Plateau through Grove Creek Canyon to Cooke City. His surveyors spent sixty days locating a new route, but the physician's funds ran out before they could complete their maps.

In 1921, the future of the Black and White Trail dimmed with the passage of a new Federal Aid Road Act that year. The legislation encouraged the development of inter- and intrastate highways that connected major population centers. The Black and White Trail was, essentially, a road to nowhere, having never extended beyond the Line Creek Plateau. Because of that fact, the highway commission dropped the trail from the state highway

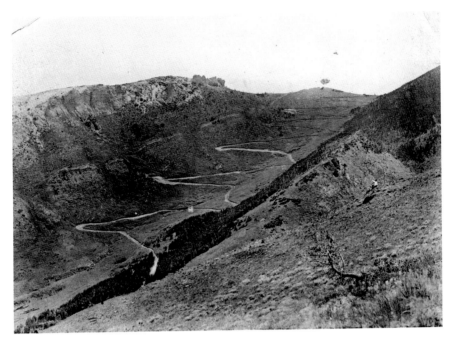

The Black and White Trail climbed via thirteen switchbacks eight hundred feet up the side of Mount Maurice, south of Red Lodge. *Carbon County Historical Society.*

system, and by 1924, Siegfriedt had abandoned the Black and White Trail. Instead, he threw his support behind a new plan to build a trans–Beartooth Plateau road to Cooke City from Red Lodge.

Though abandoned, the Black and White Trail long appeared on Forest Service maps and in promotional brochures for the Chicago, Burlington & Quincy Railroad. The trail can still be hiked, even though large trees have mostly obscured portions of it. Doc Siegfriedt died in 1940 but lived long enough to see the completion of the Black and White Trail's successor, the Beartooth Highway, in 1936.

A NECESSARY AND FEASIBLE ROAD

THE NATIONAL PARK APPROACHES ACT

Building a new entrance to Yellowstone Park by way of Red Lodge and Cooke City…will make accessible to park visitors a region of beauty and grandeur with types of scenery that cannot be found along any other roadways into the park.
—William H. Banfill, February 1931

Although abandoned in 1924, the motives behind the Black and White Trail weren't far from the minds of many Red Lodge businessmen and promoters. Part of the problem of the old trail was too many switchbacks zigzagging up the steep side of Mount Maurice and the lack of a connection once it reached the top of the plateau. The economic benefits of the route were never clear to the promoters, except as an alternate path between Billings, Montana, and Cody, Wyoming—that would have been closed most of the year because of mountain snow. Supporters needed an alternate plan if a new route across the Beartooth plateau were to be built. This time, however, the campaign for a Red Lodge–Cooke City highway would be a more potent combination of national politics and local community boosterism. Instead of lobbying the state legislature and highway commission, road proponents this time took their justifications for the road directly to Congress in Washington, D.C. The proposed road would generate intense debate in Congress for nearly a decade before President Herbert Hoover signed the legislation creating the Beartooth Highway in 1931.

The construction of a road between Red Lodge and Cooke City took on a sense of urgency in the 1920s. Red Lodge had prospered as a coal mining

town since its founding in the 1880s. Coal brought people from all over the United States and Europe to the isolated community. By 1920, the industrial town boasted a population of just over 4,500 people, with an ethnic diversity rivaled by only Butte and Anaconda. In the early 1920s, however, low coal prices, cheaper and more easily accessible coal deposits in southeastern Montana and an increasing reliance on natural gas for home heating caused the Red Lodge mines to begin shutting down. Higher-grade coal deposits in the adjacent Bear Creek drainage, seven miles to the east, became the focus of mining in the area. Unemployment in Red Lodge rose dramatically, and economic depression settled in the community. Red Lodge had to change its economic base if it was to survive and prosper. For many in Red Lodge, the answer lay across the Beartooth Plateau in Cooke City and Yellowstone National Park.

The gold, silver and copper mines boomed in the New World Mining District near Cooke City, about sixty-three miles southwest of Red Lodge, in the 1920s. Although the mines expanded in the late 1910s, there was still no reliable way to profitably ship the ore out on the railroads. Gardiner was the closest railroad terminal and was accessible for only a few months each year over a sixty-mile road that passed through Yellowstone National Park. National park officials were not happy about ore trucks in Yellowstone because it was hard on the surface of the road, interfered with tourist traffic and could be dangerous for motorists. The park service limited truck traffic to specific hours each day to minimize the conflict with tourist traffic. The restriction prevented the mines from reaching their full potential in development and production. The mine owners and the National Park Service eagerly looked for alternatives to transporting the ore across the park. A road across the Beartooth Mountains to Red Lodge seemed to them a viable solution to the problem.

Red Lodge promoters were also keenly aware of the recreational opportunities offered by the nearby national forests for tourists and area residents, but the lack of access seriously limited that use. Doc Siegfriedt actively promoted the Beartooths as a recreational paradise that could be reached via the Black and White Trail. He transferred his enthusiastic support from the Black and White Trail to a new route with his characteristic exuberance. The possibility of a new entrance into Yellowstone Park sparked dreams by local businessmen of Red Lodge as a gateway to the park, as well as an outlet for Cooke City ore. A highway between Red Lodge and Cooke City would also allow access to marketable timber in the national forests and raised the possibility of summer homes being located along the route.

A connection to Cooke City and Yellowstone National Park clearly provided an alternative to the city's depressed economy following the closure of coal mines in the community.

The key in many supporters' minds for the road was the thousands of acres of federally owned land between Red Lodge and Cooke City and the recent passage of a Federal Aid Highway Act with provisions for highways across national forests. In November 1924, *Carbon County News* publisher and editor O.H.P. Shelley traveled to Washington, D.C., to petition the Bureau of Public Roads (BPR) and the United States Forest Service (FS) to survey a route for the road across the Beartooth and Shoshone National Forests to determine if a road was even feasible. With Montana congressman Scott Leavitt's assistance and under pressure from the National Park Service to find an alternative to trucking through Yellowstone Park, the BPR and the FS (both were under the control of the U.S. Department of Agriculture) conducted a reconnaissance survey of a potential route in 1925. Both the BPR and FS declared at the conclusion of the survey that a route over the Beartooth Plateau was not only possible but also essential to the economic development of the region.

THE FATHER OF THE BEARTOOTH HIGHWAY: O.H.P. SHELLEY

At one time in Montana's history, newspaper publishers and editors wielded an enormous amount of political influence in the territory and state's communities. Newspapers were the primary source of information to people in those days, and many were anything but objective in their coverage of national, state and local events—and especially politics. Men such as Oliver S. Warden of the *Great Falls Tribune*, Will Campbell of the *Helena Independent* and Miles Romney of Hamilton's *Western News* were prominent members of their communities, and what they published held a tremendous sway over their readers. One leading publisher/editor was Oscar H.P. Shelley, publisher and editor of the *Carbon County News* and the *Red Lodge Picket-Journal*.

Born in Albany, Kentucky, in March 1875, Shelley came to Montana in 1904 and settled in Helena, where he worked as a life insurance salesman. Helena voters elected him a city alderman in 1908, a position he held until 1914. From 1914 to 1916, he was the state manager for the Cal State Life Insurance Company, the secretary-treasurer for the

A vocal advocate for Carbon County, newspaper publisher O.H.P. Shelley successfully lobbied Congress for support to build the Beartooth Highway. *Carbon County Historical Society.*

Progressive Publication Company and a member of the Central Committee for the Montana Progressive Party, a somewhat radical Republican Party offshoot. Shelley, like Doc Siegfriedt, was a Republican and an incorrigible joiner of clubs and civic organizations. He was a member of several civic and fraternal organizations in Helena and the founder of the Montana chapter of the Modern Brotherhood of America, a fraternal organization composed of insurance agents that reached its peak in the United States in the 1910s.

Shelley was also prominent in Montana's Republican Party, serving as state representative for Theodore Roosevelt's Progressive (Bull Moose) Party in 1912. He published the Montana *Progressive* in 1914 and served on the Republican National Committee from Montana from 1920 until he moved to Red Lodge in 1924. In 1920, he represented Montana at the Republican National Convention that nominated Warren G. Harding for president. In 1921, Harding appointed him a federal Prohibition officer for Montana. He resigned his position after charges that he accepted bribes from Great Falls and Lewistown breweries to permit them to manufacture beer of more than the legal 0.5 percent alcohol limit; he was acquitted of that charge in 1923.

In 1924, Shelley bought the *Carbon County News* and the *Picket-Journal* in Red Lodge, beginning a nearly twenty-year career as one of the city's most passionate and popular promoters. He also owned interests in newspapers in Great Falls and Lewistown and was the organizer of the short-lived *Red Lodge Daily News* in 1931. Shelley supported a number of projects on Red Lodge and Carbon County's behalf during his tenure on the newspaper, most important of which was his successful

lobbying for the Beartooth Highway. He was also a thorn in the side of the National Park Service's administrators during the construction of the road, particularly the service's Landscape Division. Shelley often questioned design choices on the road's bridges, threatened park service superintendent Horace Albright about them on occasion and generally functioned as a watchdog over the progress of the road for six construction seasons. Shelley was present when construction began on the road in September 1931 and was there when the highway officially opened in June 1936.

Through the 1930s and into the 1940s, he remained a force to be reckoned with in south-central Montana and in statewide Republican politics. Twice married, Shelley had three children. O.H.P. Shelley died in Red Lodge after a short illness in April 1943.

Initially, much of the lobbying done by Montana boosters for the road in the 1920s didn't focus so much on adding a new gateway to Yellowstone National Park from Red Lodge as it did on developing the mineral resources of the New World Mining District outside Cooke City. Indeed, the rhetoric for the highway in Red Lodge advocated the national park gateway locally, but when lobbying in Congress for the route, it concentrated primarily on access to Cooke City and for better access to timber in the national forests—both sources of revenue for the federal government. Leavitt and Shelley also sold the idea of the road to congressmen by suggesting that it would generate income in the form of home site leases on land adjacent to the proposed road. It was not until late in the decade that the potential route's scenic and recreational benefits became a major selling point for the highway's supporters in their lobbying efforts in Congress.

The federal government's declaration of the route's feasibility in 1925 caused a new sense of resolve among Montana supporters of the project in 1926. The Federal Aid Highway Act of 1921 allocated funds to the states for road construction but required that the states provide money to match the federal apportionment. Congress intended the milestone 1921 legislation to expedite the construction of an interstate highway system by limiting the mileage on which federal funds could be spent and encouraging connections between Federal Aid roads in adjacent states. Many states enacted gasoline taxes or floated bonds to provide the necessary matching funds for the federal money. Montana chose to enact a minimal gasoline tax in 1921 with

the bulk of the money going to the counties. The counties provided the match for federal funds, not the State Highway Commission. With a mere small percent of the state's gasoline tax revenue, the highway commission provided road and bridge plans, oversaw the bidding process and placed engineers on the projects to ensure that the contractors followed the plans.

The counties, though, were plagued by drought and a lingering economic depression that followed World War I. Drought also caused many people to flee Montana in the 1920s, shrinking the counties' already strained tax revenues. The inefficient system for road building established by the Montana legislature had an increasingly negative impact on road-building efforts under the Federal Aid Highway Act as the decade wore on. Legislative sessions in 1923 and 1925 allocated more gas tax money to the counties and less to the highway commission. By 1925, the state could no longer match federal road funds and faced the prospect of returning $400,000 to the federal government. Montana would be the only state in the Union that returned federal funds in the 1920s.

What many saw as a disaster, however, others saw as an opportunity—especially in regard to Red Lodge: the Cooke City highway. When it became widely known to Beartooth Highway advocates in south-central Montana that there was potential for using that $400,000 for the construction of the highway, they acted quickly to secure the funds in Congress—with the Montana State Highway Commission's assistance. At its January 1926 meeting, the highway commissioners telegraphed a resolution to Montana's congressional delegation, asking it to support reallocation of the money to the Red Lodge–Cooke City and Belton roads since both were entirely on federally owned land.[7] Beartooth Boosters' Club president George Jeffery of Red Lodge and Ralph Wigginhorn of Billings helped the highway commission craft the resolution.

Concurrent with the highway commission meeting, Shelley once again traveled to Washington, D.C., to lobby Senators Thomas J. Walsh and Burton K. Wheeler, along with Representatives Scott Leavitt and John Evans, to secure the support of the BPR and FS and introduce a bill in Congress asking for the reallocation of Montana's Federal Aid funds. While the BPR, FS, National Park Service and Senate approved the measure, Iowa congressman Cassius Dowell killed the bill in the House of Representatives. He persuaded his peers that the allocation of the money to the Beartooth and U.S. Highway 2 projects would benefit only Montana and not the people of the United States.

The failure of the bill was definitely a setback, but it didn't dampen the spirits of the Beartooth Boosters' Club in its efforts to get the road funded and

built. A large crowd of Carbon County and Billings supporters met Shelley at the train station when he returned to Montana on January 31, 1926. Early that morning, a twenty-eight-car procession left Red Lodge for the Magic City to meet Shelley at the train depot. The caravan consisted of eighty-three people, including the Red Lodge Band and Art Lumley's "Melodians" singing group. Nearly all the automobiles were bedecked in slogans like "Cooke City or Bust" and "Red Lodge, The Gateway." The parade stopped in communities along the way to reaffirm the club's support of the Beartooth Highway and treated listeners to impromptu speeches and band concerts.

The convoy reached Billings about lunchtime "without having an accident to mar the pleasure of a pleasant trip."[8] Throngs of Billings residents lined the streets leading to the Billings Chamber of Commerce building, which provided a lunch to the group while the Melodians serenaded the hungry guests. The convoy then proceeded to the Northern Pacific Railway depot to greet Shelley as he stepped off the train and escort him to his hotel. Shelley met with the highway commissioners at the Northern Hotel and spent the day formulating plans to obtain federal money to build the trans–Beartooth Plateau highway.

Next to Shelley, the highway's most active supporter was eastern district congressman Scott Leavitt. Elected to the House in 1921, Leavitt had been a strong proponent of the economic development of Montana. In 1926, he was campaigning for his third term in the House. A Republican like Shelley and Siegfriedt, Leavitt arrived in Red Lodge in the summer of 1926 at the newspaper editor's request to view firsthand the route of the proposed highway. Leavitt and Shelley spent three days on horseback traversing the Beartooth Plateau, combining business and pleasure. Leavitt was quick to proclaim his support for the road. The *Carbon County News* reported that "they encountered new wonders and new scenes of grandeur that went unnoticed on the trips made before." Upon their return to Red Lodge, Leavitt once again affirmed his support of the project and

> *declared that in his opinion the proposed highway is absolutely necessary, not only as an entrance to Yellowstone Park but also as an outlet for the millions of feet of commercial timber in the forests which the proposed route penetrates as well as a route that will direct untold millions of tons of ore recently uncovered in the Cooke City mines.*[9]

The jaunt clearly exceeded Leavitt's expectations. Beginning in 1927, he sponsored all the bills introduced in Congress for the construction of the Beartooth Highway.

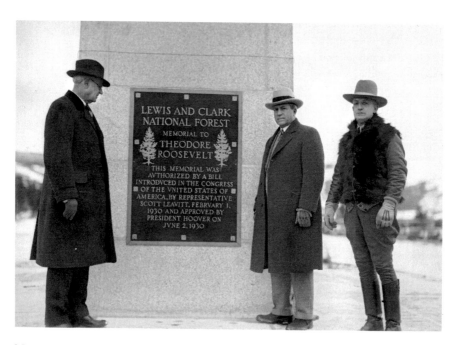

Montana congressman Scott Leavitt, second from right, was key to the passage of the National Park Approaches Act in January 1931. *MHS Photograph Archives, Helena, 944-640.*

The prospect of a road tapping into the rich Cooke City mines and the potential of a new Yellowstone National Park gateway to ease traffic congestion there compelled the BPR to authorize a survey for a road across the plateau during the winter of 1927. In late May of that year, BPR engineer Harry Mitchell arrived in Red Lodge with seventeen surveyors and technicians from the bureau's Portland, Oregon and Missoula offices to survey the rugged mountains. Born in Sandy, Oregon, in 1897, Mitchell attended Oregon State College, obtaining a degree in civil engineering in 1924. The BPR hired him shortly after graduation. The *Carbon County News* described Mitchell as "portraying those characteristics of true American manhood; quiet and unassuming…the type of man that inherently creates respect and loyalty from his field men."[10]

Before the survey began, the Beartooth Boosters' Club fêted Mitchell at a banquet held in Red Lodge. In an after-dinner speech, he indicated to an attentive audience that the bureau was firmly behind the project and "that when the road was completed it would one of the best and scenic in the country."[11] Mitchell and the BPR, apparently, supported the project more for its association with Yellowstone National Park than for its connection to Cooke City. The survey began on May 24, with Mitchell expecting its

Bureau of Public Roads engineer Harry Mitchell (left), with O.H.P. Shelley, surveyed the route of the highway and supervised its construction. *Carbon County Historical Society.*

completion in late September or early October. The *Carbon County News* followed the survey crew as it climbed up and over the plateau, reporting on the surveyors' progress, significant geographical features that were crossed and the morale of the crew members. When Mitchell completed the survey in the second week of October, he told the newspaper not only that the road was feasible but also that the necessity for it "was greater than he had anticipated."

Within weeks of the completion of the survey, Shelley returned to Washington, D.C., to resume his lobbying efforts for the proposed highway. For over a month, he met with senators, politicians, agency heads

During the summer of 1927, BPR engineer Harry Mitchell and his crew surveyed the route of what would become the Beartooth Highway. *Carbon County Historical Society.*

and anybody important who would listen to him about the need for the highway and the benefits it would have for not only the people of Montana and Wyoming but also the American people as a whole. He was able to convince acting secretary of agriculture R.W. Dunlap of the need for the road. Dunlap's support of the project was critical because the BPR and FS were agencies within the department that would ultimately control the federal funds for the highway's construction.

In 1927, Shelley testified before the Senate Committee on Post Offices and Post Roads that ore trucks passing through Yellowstone National Park from Cooke City were creating an intolerable situation for the park service and tourists visiting the park. By now, Shelley had become an accomplished lobbyist on behalf of the road and knew the right things to tell the government committees. In this case, he claimed the proposed road would divert commercial hauling through the park, thereby increasing the mining output from the Cooke City mines. This, he maintained, would "afford a great financial return to the Government," enable access to the forests for fire protection and "provide the U.S. financial opportunities through building and renting 'summer homes' along the road."

Yellowstone Park superintendent Horace Albright also appeared before the committee and corroborated much of Shelley's testimony. Albright disagreed with Shelley's conclusion that the road would be a new entrance to the national park, however. Instead, he told the committee that it was not necessary as an entrance to the park but would provide another "very scenic gateway." The Senate committee recommended passage of Senate Bill 3874, which would authorize construction of the highway. The road, the committee concluded, would provide "ingress and egress" to and from Cooke City other than through Yellowstone National Park, create a new entrance to the park to relieve traffic congestion, allow access for fire protection and to harvestable timber and, finally, open a "highly scenic region to tourists and campers." The bill died in committee but was revived in a slightly different form in January 1930 as House Resolution (HR) 12404.

Ultimately, the 1929 stock market crash and the onset of the Great Depression worked in favor of the legislation for the Red Lodge–Cooke City road. In January 1930, two bills were introduced to Congress for the funding and construction of the road. Congress debated only one: HR 12404. Introduced by Montana's Scott Leavitt and popularly known as the Leavitt Bill, it amended the 1924 National Parks Roads Act to include approach roads to the national parks. The House Committee on Public

National Park superintendent Horace Albright also played a critical role in the construction of the Beartooth Highway. *Library of Congress.*

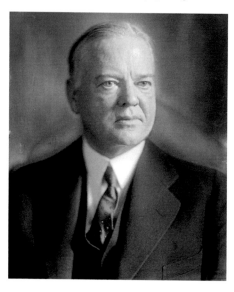

After many years of debate in Congress, President Herbert Hoover signed the National Park Approaches Act into law on January 31, 1931. *Library of Congress.*

Lands reported favorably on the bill, stating that its purpose was to aid in the construction of "adequate connections between the highway systems of the various national parks and the Federal Aid highway systems outside the national parks."[12]

Despite the seeming attractiveness of the bill, it crept through the House and Senate in 1930. What appealed to Washington, D.C. politicians was how the proposed highway would put the unemployed to work and provide connectivity to highways outside the parks—a key detail to the passage of the bill. The connectivity suggested all-important economic development during the first years of the national economic depression and also satisfied the needs of the traveling public. The proposed Federal Aid Highway Act of 1930, which passed before the introduction of this legislation, increased money available to the states from $75 million to $125 million. Importantly, that meant money available for highways located on federal lands also increased, from $7.5 million to $12.5 million. Political wrangling and debate followed the introduction of the bill until January 31, 1931, when President Herbert Hoover signed the National Park Approach Roads Act.

THE NATIONAL PARKS APPROACHES ACT OF 1931

The National Park Approaches Act provided for the construction, reconstruction and improvements to roads and trails in the national parks that were under the jurisdiction of the National Park Service. Section 4 of the act was the real gut of the legislation, while Section 5 stated the amount of money available for approach roads for fiscal years 1932 and 1933. Importantly, Section 5 also stated that the park service could enter into agreements with state and county governments to maintain the roads. That particular provision would prove easier said than done:

> Section 4. Whenever the Secretary of the Interior shall determine it to be in the public interest he may designate as national-park approach roads and as supplementary parts of the highway systems of any of the national parks roads whose primary value is to carry national park travel and which leads across lands wholly in the extent of 90 per centum owned by the Government of the United States and will connect the highway within a national park with a convenient point on or leading to the Federal 7 per centum highway system: Provided, That such approach roads so designated shall be limited to not to exceed sixty miles in length between a park gateway and such point on or leading to the nearest convenient 7 per centum system road; or, if such approach road is on the 7 per centum system, it shall be limited to not to exceed thirty miles; Provided further, That not to exceed forty miles of any one approach road shall be designated in any one county.

One of the purposes of the Approaches Act was to provide connectivity to existing Federal Aid highways. The Federal Aid Road Act of 1921 specified that the states identify 7 percent of their total mileage (state and county roads), which would then be eligible for federal funds for improvements. The Seven Percent System was one the most important provisions of all the Federal Aid highway acts passed by Congress between 1916 and 1956.

The legislation gave the secretary of the interior the authority to designate national park approach roads when he deemed it to be in the public interest and whose primary value was to carry traffic to the national parks. The government placed restrictions on what would constitute an approach road: the route could be only sixty miles in length with no more than forty miles of any approach road located in any one county. An approach road, moreover, could only cross lands under at least 90 percent federal ownership. Congress intended the legislation to apply to three national parks: Yellowstone, Yosemite and Sequoia. Evidence suggests, however, that the law was, in fact, intended specifically for the Red Lodge–Cooke City highway. The federal government appropriated $3 million to fund the construction of approach roads over a two-year period. The cost of the Red Lodge–Cooke City road alone would require much of the allocated money.

Hoover's signing of the National Park Approaches Act was undoubtedly influenced by the increasing damaging effects of the Great Depression. Just over one month prior to the signing of the Approach Road Act, President Hoover enacted the Emergency Construction Act of December 20, 1930. The legislation allocated $80 million for Federal Aid projects, along with $3 million for projects on Forest Highways and roads across federally owned and administered lands. The states used the emergency funds as matching money for the regular Federal Aid Road Act appropriations. The president and Congress intended the National Parks Approaches and the Emergency Construction Acts to put unemployed men to work on highway and bridge construction projects to lessen the impact of the Depression.

Shelley telephoned news of Hoover's authorization of the National Parks Approaches Act within minutes of his signature on the bill. The news sparked "civic demonstration and rejoicing by Red Lodge citizenry." When Shelley returned to Red Lodge, its citizens honored him with a banquet rumored to be the largest ever held in Carbon County. After many years of expectation and disappointment, the construction of the Beartooth Highway was assured.

THE GREATEST PIECE OF ROAD IN AMERICA

BUILDING THE BEARTOOTH HIGHWAY

It seems to me the location is perfectly chosen to reveal the greatest scenic treats imaginable and that the engineering accomplishment represented in that stretch of highway reflects the highest possible credit upon the engineering genius of the United States.
—*Montana congressman Roy E. Ayers, September 1934*

O nce Hoover signed the Park Approaches Act legislation and the celebrations died down in Red Lodge, events moved quickly toward construction of the road. By March 1931, Secretary of the Interior Ray Lyman Wilbur announced that the survey and plans for the road were completed and that $1 million for construction would be available for its construction on July 1, the start of the new federal fiscal year. Secretary Wilbur estimated the cost of the project, which he thought would take four years to complete, at $5.4 million (the final cost of the road was a little over $2.5 million).

In the spring of 1931, Bureau of Public Roads (BPR) civil engineer Harry Mitchell and his crew resurveyed the 1927 route across the Beartooth Plateau and reset the centerline stakes. Because of his knowledge of the route, the BPR assigned Mitchell to serve as its supervising engineer for the project. The route, Secretary Wilbur enthused, would reach an altitude of nearly eleven thousand feet above sea level with a grade not to exceed 5 percent for its sixty-eight-mile length. From one point on the road, thirty-two lakes

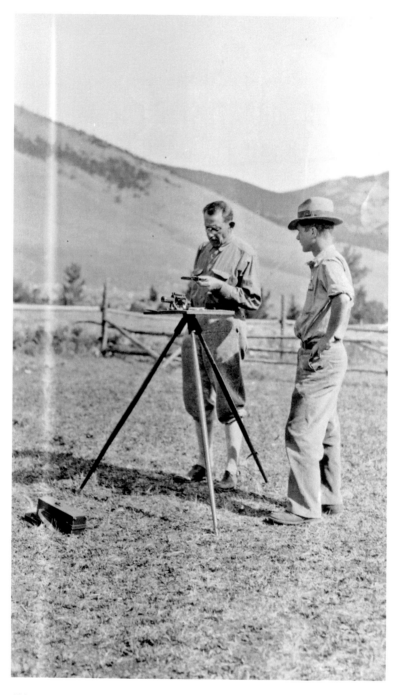

Although the Bureau of Public Roads surveyed the route in 1927, it had to resurvey much before construction began in 1931. *Carbon County Historical Society.*

would be visible to motorists. Bureau of Public Roads engineers planned for a road fourteen feet wide, based on the Forest Highway standards of the time, with a crushed gravel surface. In keeping with the park service's design standards, the road would sport rustic wood guardrails and concrete and steel bridges faced with cut stone veneer. Importantly, the BPR and the National Park worked together to ensure "that the natural scenery is not defiled and that the construction activities are confined to the 60-foot right-of-way granted for the highway."[13]

These were heady days for Red Lodge's citizens as well. Suffering a depressed economy since the 1920s when the West Bench Mine shut down, the highway offered the community new hope for its future. With Hoover's signing of the Park Approaches Act, real estate values in Red Lodge surged, and many residents of the town walked "about in the exuberance of the dawn of a new day." Others planned to take advantage of the thousands of motorists they anticipated would tour the scenic route. Entrepreneurs made plans for "oil and gas stations…at strategic points on the route leading to the approach road, hotel and café accommodations…and maps of the proposed route are being scanned with the idea of locating summer home sites conveniently near its course." Indeed, O.H.P. Shelley and Congressman Scott Leavitt made revenue from summer home sites along the route one of their marketing points for selling the idea of the highway to Congress. Citizens also investigated the possibility of building a smelter at the town to process ores mined near Cooke City. Red Lodge residents fully realized that the new highway would make the community an "entrance town" for Yellowstone National Park and, essentially, change its character.[14]

The BPR divided the sixty-eight-mile highway into four sections, designated A, B, C and D. The bureau would let the contracts for Segments A and B first. The first two segments would involve the difficult alpine section up the side of Rock Creek Canyon and over the Beartooth Plateau. Segments C and D were the connecting roads to Yellowstone National Park on the west and Red Lodge to the north. The Park Approaches legislation limited the highway to sixty miles. Consequently, in March 1931, the Montana State Highway Commission agreed to extend the Federal Aid highway eight miles south from Red Lodge to connect with the northern terminus of Segment C. The BPR initially estimated the project would take four construction seasons to build between 1931 and 1934.

At the time President Hoover signed the National Park Approaches Act, Montana was at its maximum for highway miles. In order to keep within the 7 percent limit and provide the connectivity that the act required, the

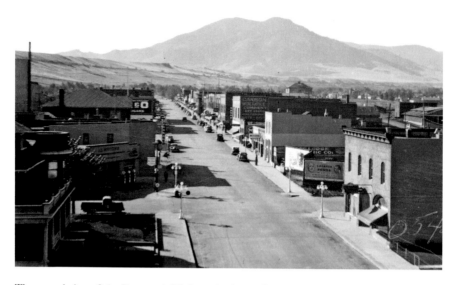

The completion of the Beartooth Highway had a profound impact on Red Lodge, transforming it from a mining camp to a prominent resort community. *Carbon County Historical Society.*

highway commission removed the eight miles of Federal Aid primary system between Red Lodge and Bearcreek and then added it from the northern terminus of the Beartooth Highway to Red Lodge. That made construction of the eight-mile segment south of Red Lodge the responsibility of the highway commission rather than the Bureau of Public Roads.

Prior to the contract letting in June, Mitchell and Beartooth National Forest superintendent R.T. Ferguson escorted ten representatives from contracting firms over the route of the proposed highway. Making the trip on horseback, the men "found plenty of thrills in the scenery…and were fully appreciative of the tourist pulling power such attractions [would] exact when the highway was completed. For business reasons, however, most of the prospective contractors maintained a pessimistic viewpoint and magnified the difficulties of construction." The reconnaissance proved daunting enough that at least one potential bidder questioned whether his company had the ability to do the job. The BPR opened bids for Segments A and B on June 26, 1931, at its Portland, Oregon office.[15]

The Boise, Idaho–based Morrison-Knudsen Company won the contract to build Segment A. This section began about eleven miles south of Red Lodge on Quad Creek and would work its way up the side of the Rock Creek Canyon over a series of tight switchbacks for twelve miles to the top

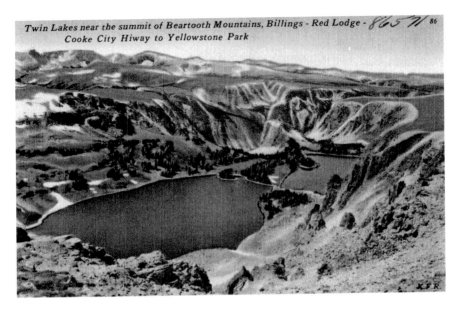

Twin Lakes near the summit of Beartooth Mountains, Billings - Red Lodge - *865 71* 86
Cooke City Hiway to Yellowstone Park

Twin Lakes was a landmark along the highway for the work crews and for tourists after 1936. *Author's collection.*

of the plateau, where it would connect with Segment B. The company was just completing a project in Yellowstone National Park when it received the BPR contract for the Beartooth Highway. The company's reputation for efficiency and the proximity of its heavy equipment to Red Lodge helped the firm get the contract. The company moved its equipment to the railhead at Gardiner and then shipped it to Red Lodge over the Northern Pacific Railway. From there, three gasoline-powered shovels, bulldozers, caterpillar graders and a fleet of dump trucks built a "tote" road south from Red Lodge to Quad Creek and then began construction up the steep side of Rock Creek Canyon to the top of the Beartooth Plateau near Twin Lakes, just north of the Wyoming border.

Segment B began near Lawrence and Olive Nordquist's dude ranch, near the Clark's Fork of the Yellowstone River on the Wyoming border. The contractor for the segment would work his way twenty-five miles up the side of the mountains and across the plateau, connecting, according to schedule, with Segment A near Twin Lakes sometime in late 1932. The BPR awarded the Segment B contract to McNutt & Pyle of Portland, Oregon, for its low bid of $476,522. Not sure if they really wanted to bid on the project, the contractors bid the project at $40,000 below the engineer's estimate. This caused some concerns with the BPR engineers, who delayed awarding both

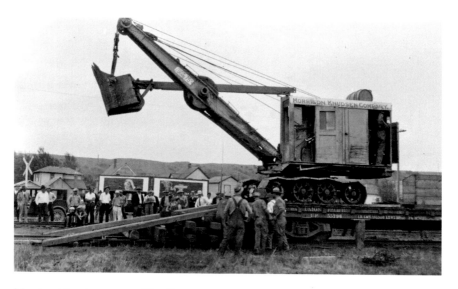

Morrison-Knudsen crews off-loading a power shovel at the Northern Pacific Railway station in Red Lodge. *Carbon County Historical Society.*

contracts until early August. As it turned out, the bureau's concerns with McNutt & Pyle were well founded. Unlike Morrison-Knudsen, McNutt & Pyle had little experience with operating heavy equipment and even less experience building roads—especially through rugged alpine territory like the Beartooth Plateau. While Morrison-Knudsen was a model of efficiency on its part of the project, McNutt & Pyle was in disarray for most of its time in the Beartooth Mountains.

Unlike Segment A, which would primarily require rock excavation work, McNutt & Pyle would need to construct bridges over the Clark's Fork River and several creeks, fill marshy areas on top of the plateau and carve a highway through a field of glacial boulders on top of the plateau. While Morrison-Knudsen benefitted from the proximity of Red Lodge, McNutt & Pyle had to ship its equipment to the railhead at Gardiner from Oregon and then drive the machines across the northern part of Yellowstone Park to the construction zone. It took ten weeks for the contractor's equipment to reach the Nordquist Ranch. By the time snow fell in early December 1931, McNutt & Pyle had yet to begin construction on Segment B. Unlike the highly organized and experienced Morrison-Knudsen crew, the McNutt & Pyle crew left BPR supervisor Harry Mitchell unimpressed. The work crews were a ragged bunch who lacked any substantial road-building experience. One employee, Warren

McGee, later remembered the contractor's camp "as one of the roughest kind and the workers employed there as roustabouts."[16]

Meanwhile, Morrison-Knudsen had established a substantial work camp on Rock Creek (now the site of the Custer National Forest's M-K Campground), south of Red Lodge, and worked diligently on carving the road up the side of the Rock Creek Canyon. The Morrison-Knudsen camp consisted of prefabricated wooden buildings that provided barracks for the workers, individual lodgings for the foremen and their families, a mess hall, a cookhouse, storage buildings and machine shops. Poker entertained the men during the off-shift hours. The cooks supplemented the camp menus with trout and venison. Bureau engineer Guy Edwards later reported that the Morrison-Knudsen camp "closely [approached] the ideal camp for a contract of this size and type, and it is believed that the very favorable and orderly living conditions…had a most important effect upon the morale of the personnel and was largely responsible for the economical and excellent operations of this contract."[17]

Federal regulations required both contractors to abide by local wage scales and, because of high unemployment in Montana and Wyoming, hire local labor to work on the road. While Morrison-Knudsen quickly mobilized its forces and began work on the road in August 1931, McNutt & Pyle was somewhat lazy in its efforts to organize its workers and get the machinery to the construction site in a timely fashion. The project attracted unemployed

In the late summer of 1931, Morrison-Knudsen built a substantial base camp near Rock Creek for its operations on Segment A. *Carbon County Historical Society.*

The M-K camp included shops, storage, a mess hall, cabins for the company foremen and dormitories for its employees. *Carbon County Historical Society.*

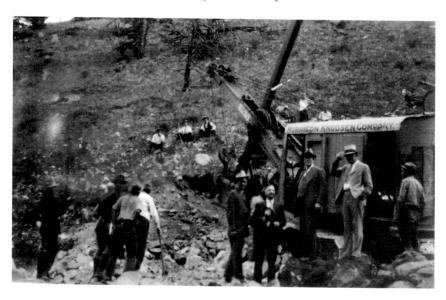

J.C.F. Siegfriedt and O.H.P. Shelley watched as the Morrison-Knudsen shovel "bucked into the rock and tore away the first mouthful of Beartooth granite." *Carbon County Historical Society.*

men and their families from all over Montana and Wyoming. The contractors received hundreds of applications from men desperately seeking work for a limited number of positions. Some had traveled to Red Lodge from a great

distance on "unauthorized assurances that plenty of employment for all comers was to be had here." The sizes of the work crews fluctuated depending on the work and averaged around 150 men. Doc Siegfriedt and O.H.P. Shelley stood by when Morrison-Knudsen's power shovel "bucked into the rock and tore away the first mouthful of Beartooth granite."[18]

POINTS OF REFERENCE

Three resorts and dude ranches were important to the early history of the Beartooth Highway: Piney Dell, Richel Lodge and the Nordquist Ranch. They provided reference points for the Bureau of Public Roads and the contractors who built the highway. All three benefitted from the completion of the road as well. Only one, however, still survives: Piney Dell.

The ubiquitous Dr. J.C.F. Siegfriedt opened Piney Dell resort southwest of Red Lodge in the early 1930s. The building originated as a log cabin built in the 1920s. As a physician in the ethnically diverse communities of Red Lodge, Washoe and Bearcreek, he sought ways to break down the barriers between the nationalities. One way to do that, Siegfriedt believed, was to construct Piney Dell. He urged the use of the building by different groups as a "cultural center for music and dance from the old countries and as a community meeting place." Today, Piney Dell functions as an upscale restaurant adjacent to the Rock Creek Resort south of Red Lodge.

Herbert and Marian Richel established a small family resort at the confluence of Rock Creek and Lake Fork south of Red Lodge in 1921. A former milliner, Marian intended the resort as a place "where city children could learn the joys of outdoor living." Activities there included swimming, fishing, climbing and stories around the campfire. Central to the resort was a log lodge that included guest rooms and a dining room. True to Marian's hopes, many of the resort's guests were "dudes" from eastern cities. Richel Lodge also "hosted conventions, political rallies, dances, class reunions, parties" and, from 1931 to 1936, highway construction workers. Richel Lodge burned to the ground in September 1966.

In the early 1920s, Lawrence and Olive Nordquist founded the L Bar T Ranch near the Clark's Fork River about twelve miles east of Cooke

Richel Lodge was a destination point for eastern dudes beginning in 1921. During the highway project, it was a staging area. *Author's collection.*

City near the Wyoming border. The dude ranch's most well-known guest was a young writer named Ernest Hemingway, who spent summers there from 1931 until the Beartooth Highway was completed in 1936. He loved fishing the river, the seclusion and the scenery. So much so that he penned his novel *The Green Hills of Africa* at the ranch in 1935. With the completion of the highway in 1936, Olive divorced Lawrence and moved to Cooke City, where she built a log cabin camp for tourists. Her ex-husband soon followed, building a lodge and restaurant in the rapidly growing tourist community.

Morrison-Knudsen and McNutt & Pyle used the same method for building the road. Both employed three power shovels. The lead shovel, called the "pioneer," broke ground ahead of the other two as it excavated a rough path up the mountainside. The two power shovels following it widened the path into a fourteen-foot-wide road and, later, a twenty-two-foot-wide road grade. Bulldozers, graders, dump trucks and an army of pick and shovel men followed the power shovels. Blasting crews worked ahead of the pioneer shovels. In September 1933, McNutt & Pyle blasting foreman Glen Welch was killed when a dynamite charge prematurely exploded on the track between Gardner Lake and Mirror Lake. Other accidents were

Motorists on the Beartooth Highway are often quick to comment on the work it took to build the road. *National Park Service, Historic American Engineering Record.*

limited primarily to dump trucks backing up too far and falling over the side of the embankment; in all cases, the drivers jumped to safety.

Morrison-Knudsen diligently carved its way up the Rock Creek Canyon wall on Segment A. The narrow path cleared by the pioneer shovel left little room for maneuvering the shovel and dump trucks. Drivers headed their trucks toward the shovel, which loaded the excavated material into the trucks over the cabs. The drivers then backed down the path and dumped the material over the embankment. Bulldozers graded the road and kept it, as the *Red Lodge Picket-Journal* noted, "in such a condition that a passenger car could travel over the job at a speed of 25–30 miles per hour at all times." The pick and shovel crews brought up the rear, prying off loose rocks and smoothing the road in preparation for the gravel and, later, asphalt surfacing.

Weather was always an issue for the contractors. Because of the nature of the rocky topography on Segment A, snow didn't close down construction during the winter of 1931–32. It would not be so lucky the next winter, when snow shut down the contractor for the season in December. As the

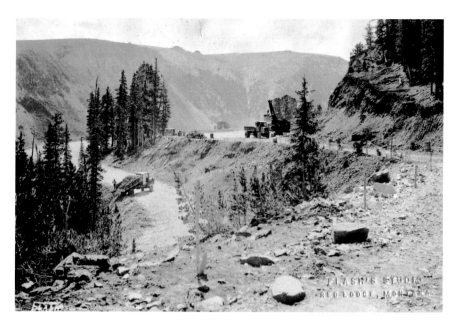

Power shovels following the pioneer shovel on Segment A widened the road and dressed up the steep slopes bordering the highway. *Flash's Photography.*

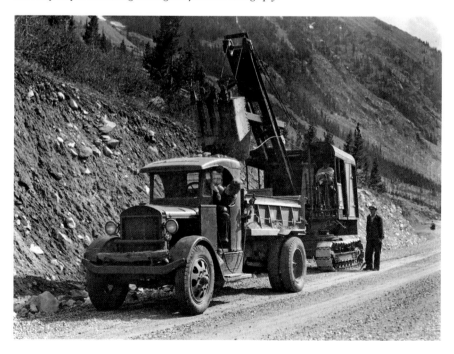

Like Morrison-Knudsen on Segment A, McNutt & Pyle was dependent on power shovels and dump trucks for much of its work. *Flash's Photography.*

The neon Red Lodge Café sign has been a city landmark since 1948. *Photo by Carroll Van West, montanahistoriclandscape.com.*

Photo by Flickr user davidkn1 (CC BY-ND 2.0).

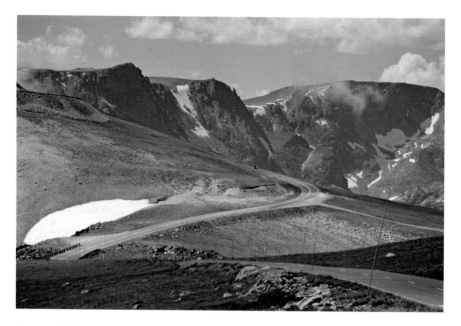

Courtesy of Phil Armitage.

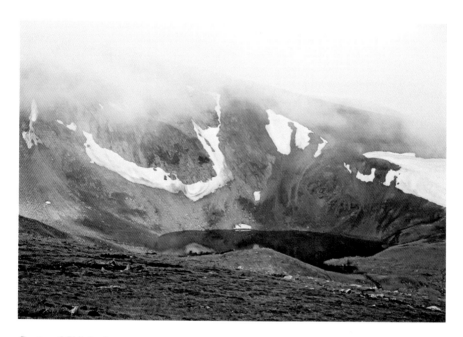

Courtesy of Phil Armitage.

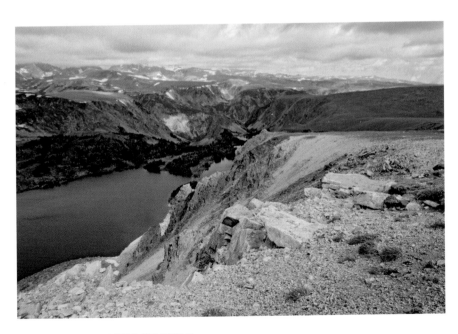

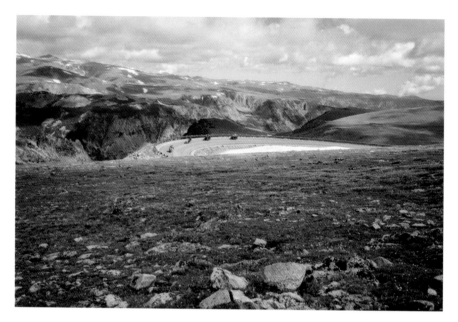

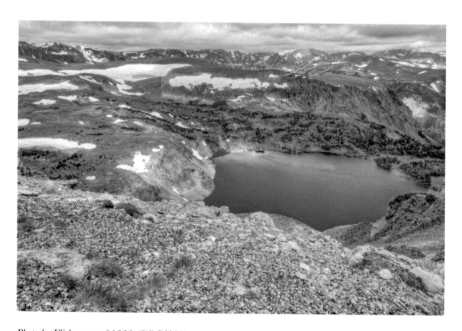

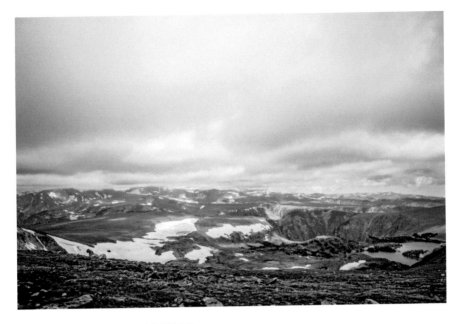

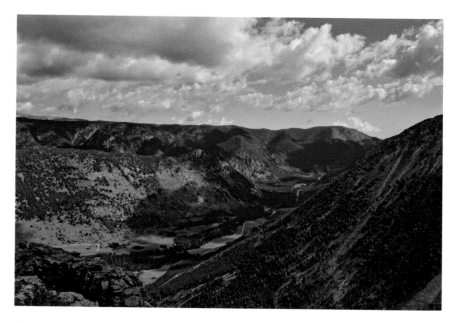

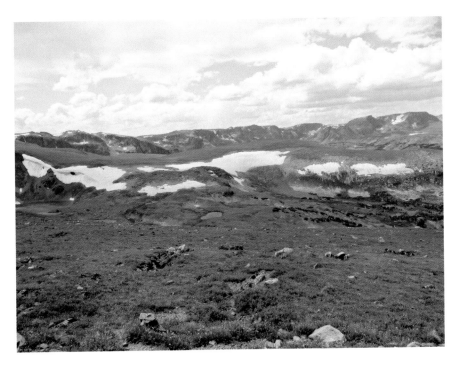

Photo by Flickr user Alex1961 (CC BY-SA 2.0).

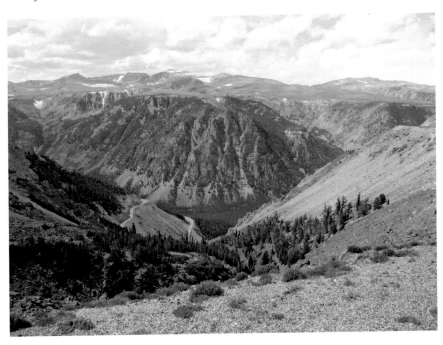

Photo by Flickr user Alex1961 (CC BY-SA 2.0).

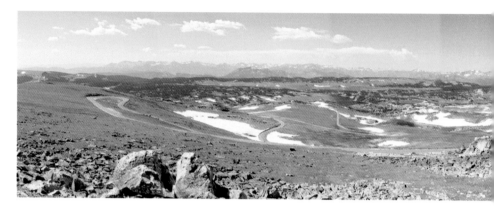

Photo by Flickr user laurascudder (CC BY-SA 2.0).

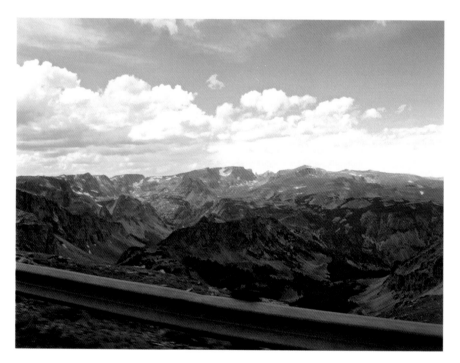

Photo by Flickr user Alex1961 (CC BY-SA 2.0).

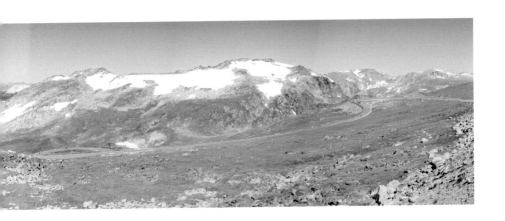

Photo by Ben Townsend (CC BY 2.0).

Photo by Ben Townsend (CC BY 2.0).

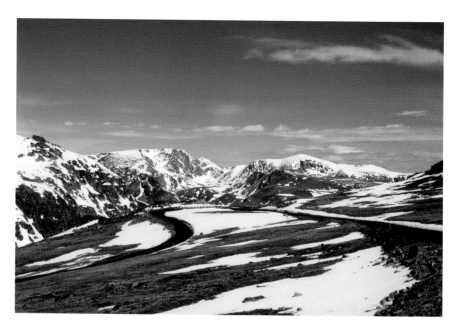

Photo by Ben Townsend (CC BY 2.0).

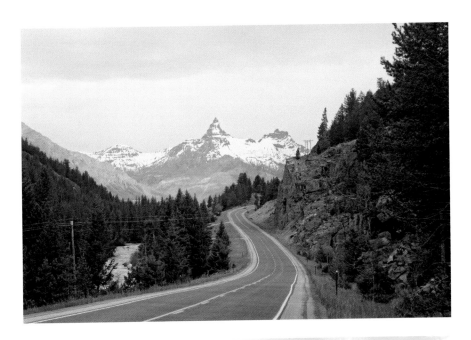

Above: Photo by Ben Townsend (CC BY 2.0).

Right: Photo by Caden Crawford (CC BY-ND 2.0).

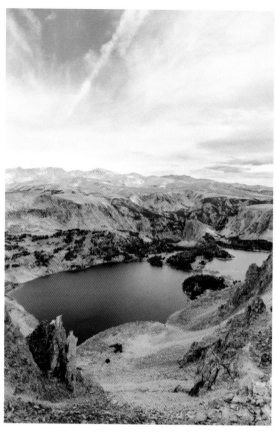

Left: Photo by Caden Crawford (CC BY-ND 2.0).

Below: Photo by Flickr user davidkn1 (CC BY-ND 2.0).

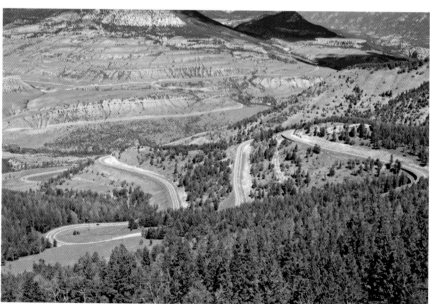

Photo by Flickr user davidkn1 (CC BY-ND 2.0).

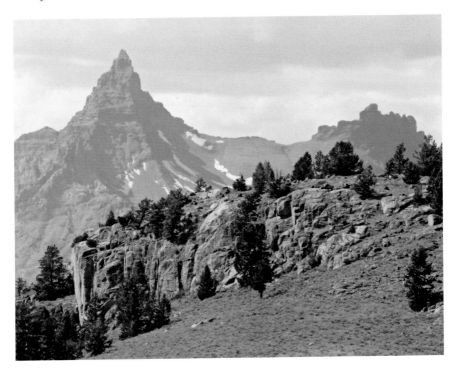

Photo by Flickr user Hilary (CC BY 2.0).

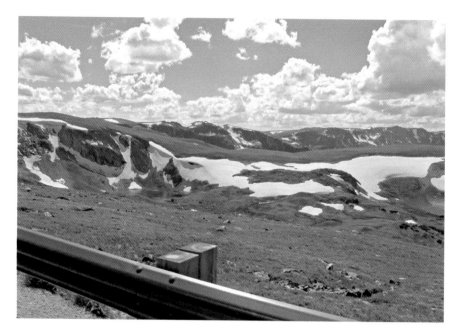

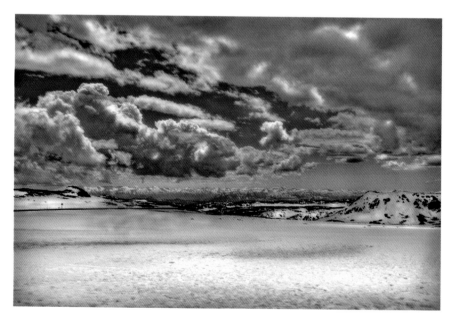

Photo by Michael Wifall (CC BY-SA 2.0).

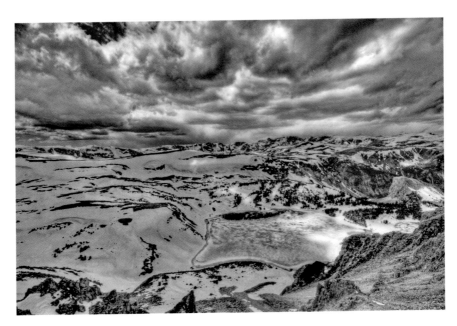

Photo by Joseph Sparks (CC BY 2.0).

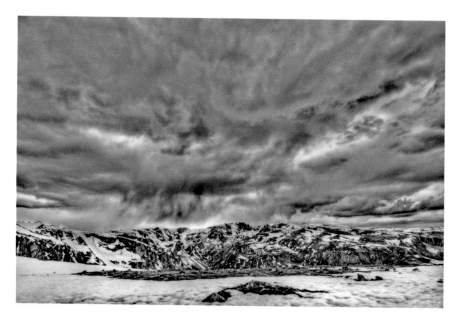

Photo by Joseph Sparks (CC BY 2.0).

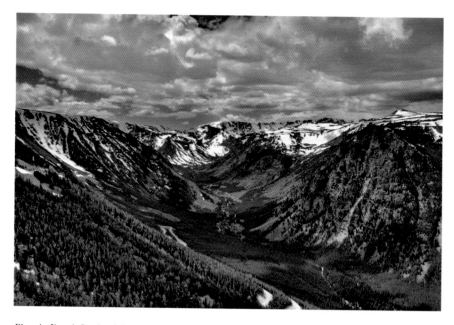

Photo by Joseph Sparks (CC BY 2.0).

work season wore on through the autumn and snow began to fall, Morrison-Knudsen constructed wooden shacks on skids that could be towed to the job sites. The workers ate their lunches in the shacks and took breaks to warm themselves in them during their shifts. For McNutt & Pyle, however, adverse weather shut its workers down in December 1931 and 1932 on Segment B. Although work resumed in May 1932 and 1933, snow drifts and sodden, marshy spots in the vicinity of the plateau's lakes hampered construction, eventually making McNutt & Pyle miss its BPR-imposed deadline of 475 calendar days to complete Segment B.

The Morrison-Knudsen team made steady progress up the side of Rock Creek Canyon, building the tightly curled switchbacks during the 1931 season, nearly reaching the top of the plateau in December. Because of its proximity to Red Lodge, the local newspaper, the *Red Lodge Picket*, provided regular reports for its readers on the progress of the contractor. Unlike McNutt & Pyle, Morrison-Knudsen's work on Segment A had clearly sparked the interest of the newspaper's readers. Segment B required

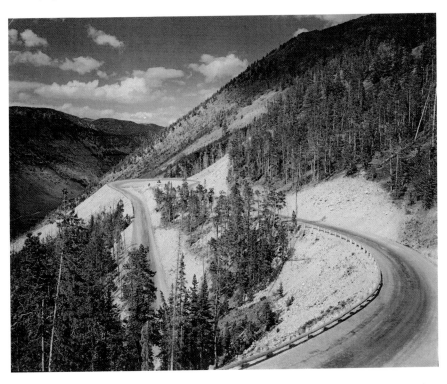

Named for the curvy Hollywood actor, Mae West Curve is just one of many features on the highway named by people who built it. *Carbon County Historical Society.*

fewer switchbacks, but the road was just as treacherous. Workers for both contractors gave descriptive names to features along the road, including Mae West Curve, Frozen Man's Curve, Lunch Meadow and High Lonesome Ridge. Those names still mark the road's landscape.

Both contractors had to contend with *Carbon County News* publisher and road advocate O.H.P Shelley. He and his cohorts made frequent inspection trips to the construction zones. In September 1932, Shelley was unhappy about the progress McNutt & Pyle was making on Segment B and about the BPR's delay in letting contracts for Segments C and D. He was especially disturbed about the masonry facing on the bridges the contractor was building over the Clark's Fork River and several creeks. Shelley wrote to National Park Service superintendent Horace Albright that the federal government had spent thousands of dollars

> *worth of* [wasteful] *expenditures with this masonry under the bridges that nobody will ever see. ...This is the first attempt they have made to change the line. In fact, I think they are an absolutely useless leech upon the park service regardless of what you may think of it, and if I ever took the photographs before the appropriation committee of this non-sensible stuff that they are doing, they might have quite a hard time to get any money to hold their job.*

Shelley's threat to take the issue up with the Appropriations Committee moved Albright to action. He dished it right back at Shelley, telling him that the bridges were standard to those within and near national parks and not any more expensive than those structures without the masonry facing on the abutments.

While he defended the decision about the abutment facing, in a letter to chief landscape architect Thomas Vint, Albright suggested that it might have been a mistake and that he should develop a justification for the design. He concluded the letter to Vint that while he didn't think Shelley would follow through on his threat, he was in a position "to deal the service and the landscape division a considerable amount of misery in the event that he wanted to stir up some trouble." Vint's justification for the design decision was, apparently, successful, as the remaining historic bridges on the Wyoming side of the Beartooth Highway still exhibit that masonry facing on the structures' abutments.[19]

Morrison-Knudsen completed its work on Segment A at the end of the 1932 construction season. The company's work on Segment A clearly impressed the BPR. Bureau chief engineer F.A. Kittredge wrote in August

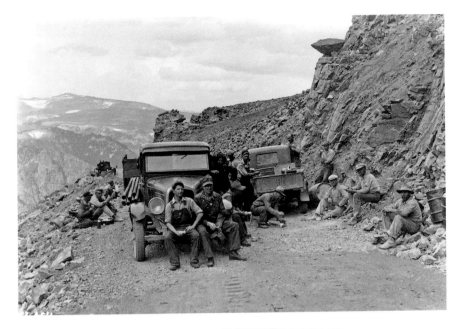

Above: Hard work earned a well-earned break for Morrison-Knudsen crew members. *Flash's Photography*.

Right: From the switchbacks, it's a long way down to Rock Creek. *Carbon County Historical Society*.

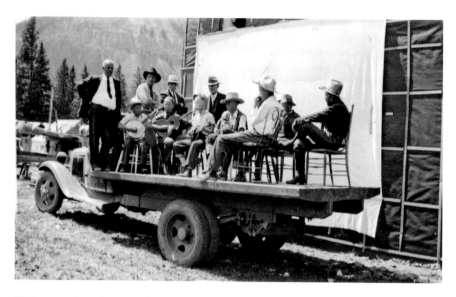

Highway projects then, as today, relied on meetings to keep the public informed about the progress of work; most don't offer live music, though. *Carbon County Historical Society.*

1934 that Morrison-Knudsen's operations was "one managed and operated in a highly efficient and economical manner and ranks among the best of the grading projects coming under [our] observation." The company then successfully bid on two more projects involving the road, including Segment C from the north end of Segment A to Doc Siegfriedt's Piney Dell resort south of Red Lodge and the grading of Segment A.[20]

Even before Morrison-Knudsen and McNutt & Pyle had completed their work, the BPR awarded contracts to build the connecting roads (Segments C and D) in November 1932. The venerable Minneapolis-based Winston Brothers company won the contract to build seventeen miles of road between the northeast border of Yellowstone National Park through Cooke City to the west end of Segment B. Segment C between Piney Dell and Quad Creek was also built by Morrison-Knudsen. In September 1932, the Montana State Highway Commission contracted with John Coverdale of Missoula to build the eight-mile connector highway from Red Lodge south to the vicinity of the Piney Dell resort to connect with Segment C.

The new contracts coincided with a change in the scope of the project. The original design for the highway specified a fourteen-foot road width and a nineteen-foot-wide grade. The BPR and National Park Service developed new design standards for forest roads that included a sixteen-foot width with a twenty-two-foot road grade. To accomplish the modification, the Forest

Service and National Park Service acquired additional rights of way to preserve view sheds and allow the wider highway. In 1933, the BPR awarded contracts that consisted of grading, placing gravel and overlaying it with a bituminous surface on the entire length of the highway. Morrison-Knudsen subcontracted with a company to install guardrails on the switchback sections. The lack of guardrails frightened many motorists, who drifted into the wrong lane to avoid the outside edges of switchbacks and thereby created a hazard for oncoming traffic.

Even before the highway was completed, the BPR allowed some traffic on the as yet unfinished road beginning in July 1932. The bureau allowed a lucky few Red Lodge rodeo visitors to drive to the top of the plateau "to view the spectacular grandeur of the Beartooths from a point never before reached by motor cars." By July 1933, McNutt & Pyle had graded a primitive track between Segments A and B on top of the plateau. Barely passable, the *Red Lodge Picket* stated that the track was not recommended for "lovers of ease and indolence." Traffic on the road increased during the summer of 1933, but motorists often had to wait for blasting and other construction activities before being able to pass. What was estimated to be a two-hour trip over the plateau to Cooke City often took many times that time with no guarantee of making it to the other end of the highway before night fell, which made the route even more adventurous for some drivers.[21]

Despite the difficulties in automobiles negotiating the road, nearly all accounts of it in local newspapers reported the stunning progress made by the highway contractors in sometimes difficult circumstances and commented on the spectacular scenery one would see all along the route. In 1934, a trade publication, the *Highway Magazine*, featured a cover photo of the road and called it "one of the most sensational mountain highways in America."[22] As work on the connector roads progressed, the contractors allowed an increasing number of motorists to travel the route as long as they expected delays because of construction. There were few complaints by travelers; nearly all recognized the unique qualities of the road and its importance to Red Lodge and Yellowstone National Park.

Work on the entire sixty-eight-mile highway occurred during the 1933 to 1935 construction seasons. McNutt & Pyle finally completed Segment B in November 1933. None of the segment contracts included provisions for placing a gravel surface on the road. In November 1933, the Minneapolis-based S.J. Groves & Sons Company obtained a BPR contract to install guardrails on sections of the highway. The BPR awarded Morrison-Knudsen a contract to surface Segments A and C in November 1932. S.J. Groves &

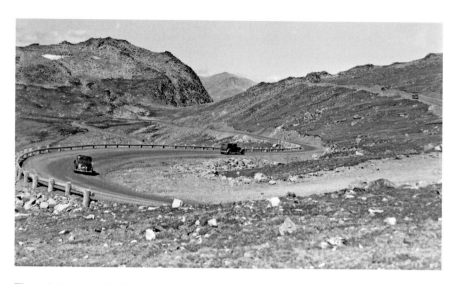

The switchbacks and tight curves of the highway have provided a thrill and a challenge to motorists since 1936. *Carbon County Historical Society.*

Sons got the contract to widen and surface Segments B and D. The BPR also contracted with Groves to place bituminous surfacing on sections of the entire sixty-eight-mile highway.

In August 1935, a Great Falls, Montana contractor, J.L. McLaughlin, won a BPR contract to widen the road from a point eight miles east of Cooke City west to the Yellowstone National Park border. The BPR also required the contractor to pave the roadway and widen it to thirty feet through Cooke City. McLaughlin completed the contract in September 1936. Prior to that, in October 1935, S.J. Groves & Sons had completed paving Segments A, B, C and D of the Beartooth Highway, essentially completing the Beartooth Highway project.

The Beartooth Highway was an engineering triumph that cost, at about $2.5 million, the federal government a little less than half what it anticipated. It was the product of many different contractors and marked a successful collaboration between the BPR, the National Park Service and the Forest Service to see it through to completion. There were only two deaths during construction of the highway, with most of the accidents consisting of dump trucks and a grader getting too close to the edge of the road and crashing down the mountainside.[23] With construction completed, Red Lodge, at least for a time, became a gateway city to Yellowstone National Park. The highway also allowed mining trucks from Cooke City to access the Northern Pacific Railway from Red Lodge. Importantly, it also opened new recreational activities in the national forest and new economic opportunities for people in south-central Montana.

OPENING THE BEARTOOTH HIGHWAY

Long cherished dreams became reality…as motorists left the heat of the northern Midland Empire to speed over an oil surfaced highway in the clouds—the Red Lodge Cooke City Road to Yellowstone National Park.
—Helena Independent, *June 16, 1936*

Lucky Red Lodge rodeo-goers got the opportunity to tour Segment A of the highway in early July 1932. The road reached only as far as the Line Creek plateau, but motorists got the first opportunity to "view the spectacular grandeur of the Beartooths from a point never before reached by motor car." National Park superintendent Horace Albright and a small party inspected the uncompleted road on Segment B from the Cooke City side of the project in August 1938. By then, however, scores of motorists had attempted to drive the route only to be turned back by the continual closing of the road by construction. Over the next three construction seasons, though, contractors allowed automobiles on the still uncompleted road.

The going was slow, however, and BPR supervising engineer Harry Mitchell warned motorists to expect delays and to travel some segments at their own risk. Despite the warnings, the number of motorists grew each succeeding year. Many reported on the progress of the highway and left glowing reports of the scenery, praise for the workmen and optimism about the highway's impact on Red Lodge, Cooke City and Yellowstone National Park in the *Red Lodge Picket-Journal*. What was clear from the public record, though, is that nobody knew exactly when the highway would be completed.

Thinking that the highway would be completed in 1934, *Billings Gazette* editor Eugene McKinnon inquired of the National Park Service about a formal opening celebration for the highway. Yellowstone Park superintendent Roger Toll responded that the park service didn't do celebrations when it completed projects, but it was OK if somebody else wanted to do it. He recommended against a ceremony that year, however, because the highway wasn't completed. Indeed, even *Carbon County News* publisher Shelley opted against a celebration in 1934 for that reason.

In August 1935, the BPR awarded what it hoped it would be the last construction contract to complete the Highway (it wasn't—the BPR

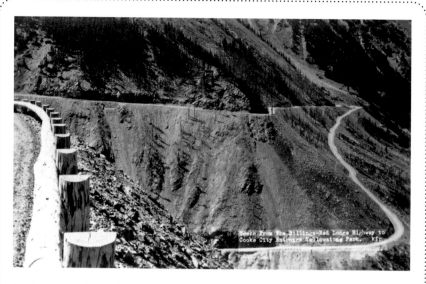

Work on the switchbacks garnered much of the attention in the *Red Lodge Picket-Journal* during the early stages of the project. *Author's collection.*

awarded contracts annually until 1939 to "dress up" the work done prior to that year). The J.L. McLaughlin Company had not yet finished paving the last eleven-mile segment of the roadway when national park and BPR spokespersons declared the Beartooth Highway officially completed.

The Beartooth Highway seems to have opened with little fanfare on June 14, 1936, after the BPR completed snow removal on the route. At least no newspapers reported any significant celebration on that date. The *Red Lodge Picket-Journal*, however, provided the only official account of the highway's official opening in a story that was picked up by other newspapers throughout Montana and the United States.

Motorists from all over the United States waited patiently for the go-ahead to ascend the highway the morning of June 14. The *Picket-Journal* reported on the "cosmopolitan crowd" from states as far away as Maine and California who began the sixty-eight-mile journey to Yellowstone National Park on "the country's highest and most novel highway." Further, the writer crowed that "the climb is not noticeable, so gradual is the ascent, so perfect is the wide, well-oiled highway." The article also advised motorists to stop at the many observation points along the highway that "fairly [beg] for the camera to set down what the eye can hardly credit."

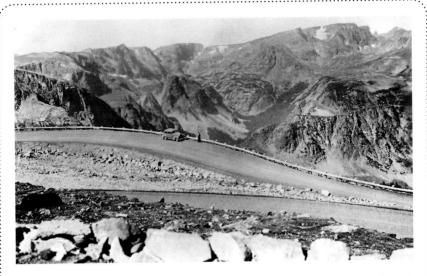

The highway's engineers designed vista points at places where photo opportunities of the scenery were particularly impressive. *Carbon County Historical Society.*

> One leaves Red Lodge for a 68 mile stretch of virgin beauty with a feeling of anticipation that will not be betrayed. For fourteen miles you drive up a scenic river grade along [Rock Creek], then climb the mountain on a series of switchbacks with guardrails to the Line Creek plateau where you ascend another series of switchbacks to the 11,000 feet altitude. Here, if you love beauty, you stop and survey the scenic panorama below...[24]

Hyperbole has, indeed, been the key to all descriptions of the Beartooth Highway since it officially opened for traffic in 1936.

6

THE TRIALS AND TRIBULATIONS OF
JACK McNUTT AND GUY PYLE

This section of the Red Lodge–Cooke City Road passes through some of the
finest scenery of the entire route. The section above timber line passes numerous
alpine lakes and eternal glaciers. Many of the lakes are a mile in length, are
immediately adjacent to the road, and offer some of the finest fishing in the world.
—Harry E. Mitchell, BPR supervising engineer, 1933

While the Bureau of Public Roads (BPR) publicized Morrison-Knudsen's efficiency on Segment A, McNutt & Pyle's operations on Segment B were strikingly different. Sloppy supervision, poor management decisions and amateurish employees were the hallmark of McNutt & Pyle's experiences on the project. To the contractor's credit, he recognized early on that he was in way over his head, but his bluster, poor organizational skills and lack of communication with the BPR and his employees proved his undoing. Despite the drawbacks, the contractor soldiered on through the difficulties to build twenty-five miles of roadway through some of the most rugged topography of the entire Beartooth Highway.[25]

The first inklings of trouble for McNutt & Pyle began even before the BPR awarded the contract to the company on June 26, 1931. In late June, the week before the contract letting, the BPR, the Forest Service and the National Park Service hosted a three-day reconnaissance of the project area for prospective bidders. Sixteen contractors, including representatives from McNutt & Pyle, scouted the proposed route of the highway on foot and on horseback. The McNutt & Pyle men, along with agents from Winston

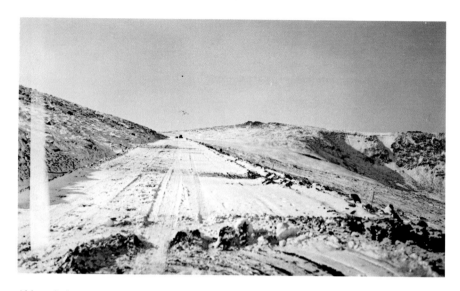

Although deep snow was a hindrance at lower elevations, high winds above the tree line often kept the highway nearly swept clean. *Carbon County Historical Society.*

Brothers of Minneapolis, went ahead of the others along the planned route in "semi-secrecy," scouting out the lay of the land.

What the company's agents saw, apparently, caused the contractor to hesitate before submitting a bid on the project. But the company did so anyway, tendering a proposal of $470,000, about $40,000 below the engineer's estimate for the project. McNutt & Pyle, perhaps unintentionally, submitted the lowest bid for Segment B. McNutt's doubts lingered, however, and the contractor considered forfeiting his 5 percent bid bond before signing the contract. McNutt's agents made another survey of the project in early July and obtained a performance bond just before the end of the grace period. McNutt & Pyle signed the contract on July 22, and the BPR issued the notice to proceed on August 5, the same day company co-owner Jack McNutt arrived in Montana to personally supervise the project.

Brothers Jack and Earl McNutt of Eugene, Oregon, founded a company that specialized in road grading projects with horse-powered equipment in the 1920s. In 1929, the brothers obtained contracts to grade part of the Oregon Coast Highway and the approach road to Crater Lake National Park. The Great Depression had a significant impact on McNutt Brothers, which struggled with outdated equipment to compete with other contractors. Consequently, the company began to acquire power machinery and merged with contractor Guy Pyle's company to more aggressively seek bigger

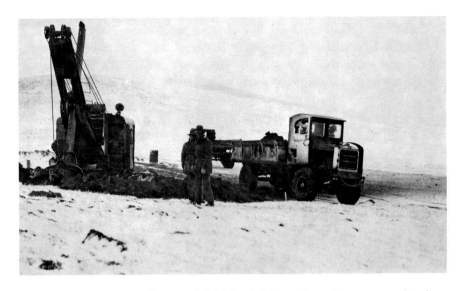

Like Morrison-Knudsen on Segment A, McNutt & Pyle was dependent on power shovels and dump trucks for much of its work. *Flash's Photography.*

contracts to keep the struggling company afloat. Guy Pyle's outfit specialized in bituminous surfacing projects, not highway construction projects. Neither McNutt or Pyle had experience with the volume of excavation that would be necessary for Segment B.

From the beginning, the BPR was dubious of McNutt & Pyle's ability to build Segment B. The company had only recently acquired caterpillars and power graders to do road work and had little experience operating the equipment and building highways, especially in a rugged alpine environment like the Beartooth Mountains. Indeed, BPR supervising engineer Harry Mitchell was "under the impression [that McNutt & Pyle] started bidding on the larger projects throughout the Northwest and, amid accusations that other contractors were combining to prevent them from obtaining performance bonds, they bid on Section B." During the time McNutt & Pyle worked on Segment B, two of the three companies that held its performance bonds went into receivership.

Unlike Morrison-Knudsen, which could cost-effectively ship its equipment to Red Lodge on the Northern Pacific Railway's branch line and then "walk" it fifteen miles to the beginning of the project, the closest railway access for McNutt & Pyle was in Gardiner, Montana, eighty miles from the beginning of Segment B over all but impassable roads. The company also relied heavily on poorly trained itinerant workers, called "gippos," to do much of the work.

There was a primitive road between Cooke City and the beginning of Segment B near the Nordquist dude ranch. Motorists occasionally used the treacherous sixteen-mile road, but only at "extreme risk" to themselves and their vehicles. McNutt & Pyle relied on that road to get its equipment to the staging area for the project. The contractor spent most of the 1931 construction season and $8,000 getting the road into good enough shape so that his equipment could reach the staging site. It cost another $3,000 to move the equipment to the work camp from Gardiner.

Once he had marshalled his equipment and men, McNutt boasted to Mitchell that in "30 days he would have them at Beartooth Lake, 10½ miles from the west end of the project through a section of glacial boulders that would cause the most experienced superintendent great concern." In his attempt to substantiate his claim, McNutt drove the inexperienced and unsupervised gippos hard at a significant cost to the company's machinery, nearly demolishing all his caterpillars in the process. Mitchell later claimed that the "state of affairs was pitiful," with broken-down trucks parked everywhere. McNutt would not reach the lake until a year later.

Despite its late start in the season, McNutt's crews began the long haul up the Beartooths to the top of the plateau. It soon became obvious to the BPR, though, that McNutt had overreached himself on the project. Shovel operations were conducted by men who were inexperienced in the use of the machinery. Likewise, the truck drivers often backed their dump trucks up over the road embankments. When this happened, the shovels had to take time off from their excavation work to tow the trucks back onto the road. Mitchell complained that the trucks were all of different capacities and the drivers of varying abilities, making the efficient operations in the construction of the road impossible. Breakdowns of equipment were common and the repair facilities poorly organized.

The McNutt & Pyle construction camp was, according to the BPR, "thrown together," consisting of a motley collection of tents. The contractor had constructed no equipment repair or storage shops by the time the shovels and dump trucks arrived in late August, nor would any be built until well into 1932. Communications with the outside world were limited to an emergency Forest Service telephone at the Nordquist Ranch, three miles from the camp. The telephone was an undependable single-line system "subject to noise and other disturbances." The telephone's central office was located in Cody, Wyoming, sixty miles from the camp. Telephone service could not be obtained for days at a time.

The highway required thousands of tons of fill material across the plateau to keep the road bed out of marshy areas. *Carbon County Historical Society.*

Many of the McNutt & Pyle employees brought their families to the primitive camp. When snow shut down construction operations in November 1931, the camp was hit hard by sub-zero weather, with temperatures sometimes sinking to twenty degrees below zero. Many of the men and their families left the camp or risked freezing to death if they stayed. Around seventy men, however, remained behind to ride out the winter. The camp included only one cookhouse consisting of a sixteen- by eighteen-foot tent designed to serve eighteen men. During that first winter, the cook served the crew three meals a day, making the cook tent "a madhouse if there ever was one," according to Mitchell.

Mechanics repaired the broken-down equipment outdoors in sub-zero weather. In one instance, the mechanics drove a truck into a vacant tent and then built a fire in front of the tent to keep warm. When the fire died down, they poured used crankcase oil on the fire, which flared up and burned the tent to ground; the men narrowly saved the truck from destruction.

Supplies for the McNutt & Pyle operation had to be trucked in from Gardiner. The contractor organized a system to haul supplies to the camp over a road that his employees derisively referred to as a "proving ground for trucks." Harry Mitchell later reported that "the trucks were loaded as long as anything would stay in, regardless of weight, and run until they either broke down, burned up or ran into each other or into a tree." The BPR engineer didn't get along with Jack McNutt, which led to violent differences of

opinions over the progress of the work. It appeared that the McNutt & Pyle operation would lag hopelessly behind schedule because of the contractor's disorganization, poor management and lack of communication with BPR personnel. The inexperienced gippos severely hampered the work, and McNutt was unwilling to get rid of them. The incompletion of Segment B by the 1932 deadline seemed a foregone conclusion.

In its effort to secure a new security bond, McNutt & Pyle merged with the contracting firm of Washburn & Hall "for financial purposes." The new company was much more experienced than McNutt & Pyle, and the BPR supported its efforts to reorganize the construction activities and logistics of McNutt & Pyle. Hall fired all the gippos and replaced them with more experienced workers whom he closely supervised. Washburn took control of the camp and supplies. Bureau engineer Guy Edwards of the agency's Division of Management obliged McNutt to cooperate with the BPR, Hall and Washburn. Although McNutt resented some of the changes, it did, in the long run, keep the contractor solvent and made it possible for him to complete the contract.

Washburn established a new camp, closer to the construction site at Long Lake, and made it large enough to accommodate one hundred men in late 1932. This camp would be McNutt & Pyle's headquarters until it completed the project. The contractor, at Hall's urging, subcontracted the construction of the bridges on the project to Fred Lindsay of Eugene, Oregon, in the spring of 1932. The company built six reinforced concrete and steel stringer bridges and was a model of efficiency. Despite the increase in efficiency, the project was still plagued by problems that were entirely the fault of Jack McNutt. In late August 1932, a cold snap caused $3,000 worth of damage to the contractor's equipment in "bursted radiators and engine blocks in one night." Because of the reorganization and despite the problems, McNutt & Pyle was within one mile of connecting with Segment A by October 1932.

McNutt & Pyle finally completed its work on Segment B on November 9, 1933, connecting it with the Morrison-Knudsen segment. During the course of the seventeen-month project, the contractor lost $80,000 in excavation work alone. Harry Mitchell's final report of the project provided much illumination about the contractor's shortcomings and very little about the more positive aspects of the project. He blamed the project's problems on

poor superintending; poor and improper handling of equipment, inexperienced shovel operators, poor shop accommodations, insufficient air equipment, poor dumpmen in the fills and the lack of coordination

between the dumpmen and the shovel operations. ...The "stressing" of the superintendent of high production in the individual units without regard to the coordination of these units.

Although Hall corrected many of the problems, McNutt had no experience in "handling work where the drilling, excavating, and hauling units were separate, nor the organization to effect the same" or competent mechanics to service the broken-down machinery.

McNutt & Pyle's troubles were not yet finished. When the company completed its work on the project, it abandoned both of its work camps without tearing down the buildings and reclaiming the area as was specified in its contract. The BPR and the park service wouldn't accept the project until the buildings had been removed and the land reclaimed. Red Lodge newspaper publisher O.H.P. Shelley was in a hurry to move on to the next phase of the project: the surfacing of the highway. So he purchased the camps from McNutt & Pyle and promised to take care of them if the federal agencies would accept the project. They eventually acceded to Shelley's demands and accepted the project from McNutt & Pyle. In 1934, however, it became obvious that the work the contractor had done on finishing Segment B was not up to standards. Much of the delay in completing the surfacing of

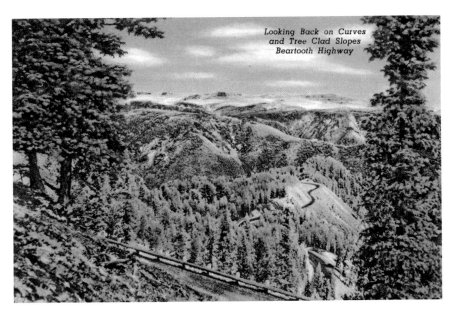

Postcards accentuated the scenic qualities of the highway and played up the switchbacks perched precariously on the edge of the Rock Creek Canyon. *Author's collection.*

Segment B experienced by S.J. Groves & Sons in 1934 and 1935 was because of the shoddy work done by McNutt & Pyle. The contractor, apparently, won no more contracts after the Beartooth Highway, and it declared bankruptcy shortly after completing its work.

During the Great Depression, situations like that of McNutt & Pyle were not uncommon, as contractors sometimes overreached themselves in order to keep their companies solvent. Other contractors on the Beartooth Highway, such as Winston Brothers on Segment D, would also have their share of problems with logistics, organization and zeal to finish the work on time and according to the specifications set by the BPR and the National Park Service. In the case of the Red Lodge–Cooke City highway, however, the BPR and park service compared all the project's contractors to the efficient operations of the Morrison-Knudsen Company, which had advantages that the others did not.

7

AN EXCELLENT ROAD CHISELED OUT
OF THE MOUNTAINSIDE

COMPLETING AND MAINTAINING
THE BEARTOOTH HIGHWAY

*It is a most wonderful highway and the scenery is such that this highway can
hardly help but rank as one of the most spectacular and interesting in the country.*
—*F.A. Kittredge, Bureau of Public Roads, 1933*

With the official opening of the Beartooth Highway in June 1936, the
first phase of the project was essentially completed. The second,
and longest phase, was about to begin: the maintenance of the "World's
Most Scenic Highway." Unlike most highways in the region, the Beartooth
Highway was open only about four months of the year. For the remaining
eight months, the road was covered in deep snow and ice. Maintenance
crews had only a short time to repair the road before it was, once again,
covered by snow. And they had to contend with the thousands of motorists
who navigated the road each summer tourist season. Initially, the road
contractors or National Park Service began clearing snow from the route
in May and completed it, depending on the weather, around the middle of
June. All this was pretty straightforward. The real issue involved who was
responsible for maintaining the highway after the road was completed and
where the money would come from. This issue arose even before the first
shovelful of dirt was turned over in 1931 and continues to be a challenge in
the twenty-first century.

When completed, the sixty-eight-mile Beartooth Highway passed through
two states (Montana and Wyoming) and two national forests (the Beartooth

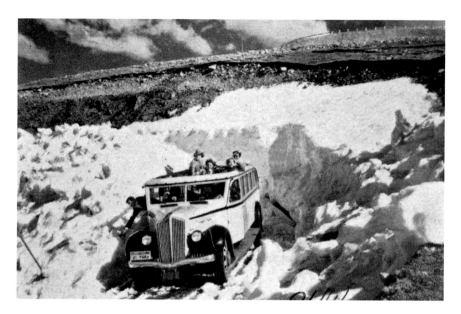

The snowdrifts along the highway were, by themselves, an attraction for riders of the Yellowstone Park tour buses. *Carbon County Historical Society.*

and Shoshone) and provided a new entrance to Yellowstone National Park. The design standards for the route were developed by the Bureau of Public Roads (BPR), which oversaw the construction process and paid the bills. The National Park Service set guidelines for landscaping along the route and specified that bridges be designed with specific features to appear "rustic." The park service's specifications were sometimes at odds with O.H.P. Shelley's vision of the highway. When the J.L. McLaughlin Company completed its last mile of bituminous surfacing in September 1936, the National Park Service had to sign off on the project before the BPR could pay the contractor's final bill.

At the time the highway was under construction, the BPR and NPS were already arguing about whose maintenance responsibility it would be when completed. The BPR tried to drag the Montana State Highway Commission into the fray in 1931. For a while, the bureau tried to simultaneously coerce the highway commission to assume responsibility of the Montana section of the road and palm off its responsibilities for the entire route on the NPS. The BPR's efforts were based on the Park Approaches Act legislation, which gave it and the park service authority to enter into maintenance agreements with state governments.

For three consecutive construction seasons, from 1937 to 1939, the BPR and the park service jointly funded the repair and stabilization work to the

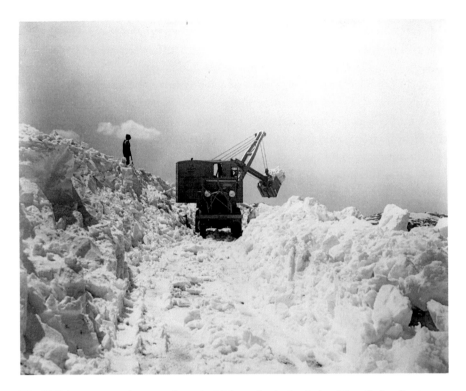

The BPR began removing snow from the highway beginning in late May. *Carbon County Historical Society.*

highway. The work included the redressing of cut slopes, repair of slides, cleaning ditches and culverts and removal of fallen rock. The work also involved widening the paved surface from nineteen feet to twenty-two feet, patching potholes and frost heaves and installing signage along the route. During the summer of 1935, the BPR supervised the installation of 1,200 feet of "rustic wood guardrail," mainly on the switchback section. Motorists driving the road were unnerved by the lack of guardrails between them and the abyss and had a tendency to drift over to the inside lane to compensate, causing a serious traffic hazard for those coming down from the plateau. Roadway repair was an annual obligation with only one year, 1938, when the road made it through the winter in good shape. The pools of federal money for maintenance, however, continued to shrink during the decade.

The NPS usually hired unskilled and skilled labor from the National Reemployment Service (NRS) in Red Lodge to work on the road. During the New Deal years of the Great Depression, the federal government imposed draconian restrictions on the hiring of men on federally funded projects.

Federal authorities and contractors could only hire men registered at local NRS offices. Those men had to prove to the officials that they were unemployed and were residents of the area where the work would take place. Men hired under the relief program worked five days a week at six hours per day for a workweek of thirty hours. The contractor or the government agency involved provided room and board; the men had to be paid in cash each week. The restrictions significantly hampered the amount of work that could be done each season, and contractors habitually violated the federal regulations to meet their BPR- and NPS-imposed deadlines. Despite the restrictions, the work on the Beartooth usually reached its maintenance goals each year.

Before the repair work could be done, the highway had to be plowed. That was also part of the problem: who was responsible for snow removal? Unlike the Going to the Sun Highway in Glacier National Park, where the work was clearly the responsibility of the National Park Service, the Beartooth Highway is not located within a national park. The earliest photographs of snow removal on the highway show Bureau of Public Roads shovels and plows removing snow. The BPR had withdrawn from that work by 1938, turning it over to the park service, which didn't think the task was its obligation. By World War II, the park service had regularly approached the highway commissions of Montana and Wyoming about taking over the duty. While the Montana State Highway Commission was generally receptive to the idea, the Wyoming commission was not. The Wyoming commissioners argued—rightfully—that the road benefitted the park, Cooke City and Red Lodge. The Beartooth Highway was a Montana project, and Wyoming didn't benefit from the presence of the road.

Other problems arose as the highway became more popular with tourists. The BPR and the park service couldn't open it fast enough each year to satisfy the Red Lodge Chamber of Commerce/Commercial Club and other regional Montana businesses. As Red Lodge became increasingly reliant on the tourist trade, the Beartooth Highway became critical to the local economy. A brochure printed by the Commercial Club in 1936, *Over the Top via Red Lodge–Cooke City Highway*, boasted:

> *"Stay a Week" in Red Lodge is the suggestion for travelers who wish to sojourn and enjoy the cool clean atmosphere, and bring your camera and fishing rod. No hay fever and no mosquitoes to bother; swimming pool of soft mountain water; saddle horses for travel trips are available; all native animals of the Rocky Mountain region are on display at the "See 'Em Alive" Zoo.*

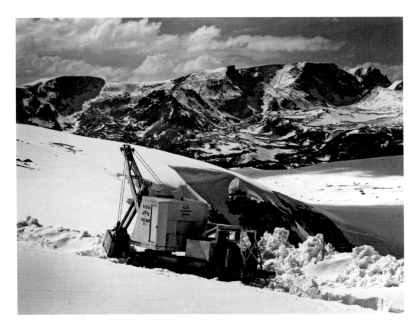

For a short time in the late 1930s, the BPR removed snow from the highway using power shovels. *Carbon County Historical Society.*

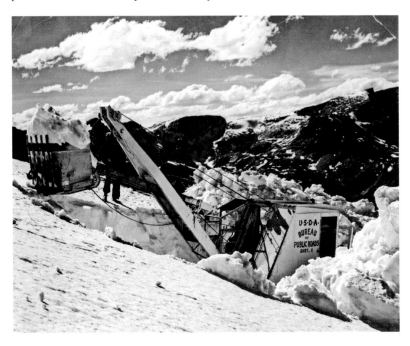

Unlike the well-organized snow removal efforts of today, BPR's shovels had little room to maneuver in deep snow. *Carbon County Historical Society.*

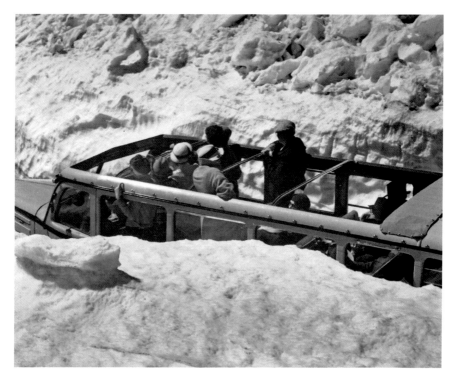

Yellowstone National Park and the Red Lodge Chamber of Commerce took tourists up the highway hard on the heels of the snow plows. *Carbon County Historical Society.*

Delays in opening the road often resulted in strongly worded letters from concerned businessmen to the BPR and the National Park Service. Not only did the delay cut into their potential profits, but it also hampered local residents from taking advantage of the road. Within a very short time, the Beartooth Highway had become an integral part of the local economy and a political issue.

The highway was also important to Cooke City's survival. Prior to the 1960s, there was no direct connection to Cooke City from the outside world for eight months of the year. With the Beartooth Highway closed for part of the year and the road from Gardiner often impassable in the winter, Cooke City businesses and residents relied on a relatively narrow window for obtaining supplies. In July 1945, Billings grocer George Keil wrote several letters to the National Park Service complaining that as long as the Beartooth was closed, he didn't have an outlet for his goods in Cooke City. Likewise, the owner of a local service station couldn't obtain gasoline and oil for the thousands of tourists passing through the community.[26]

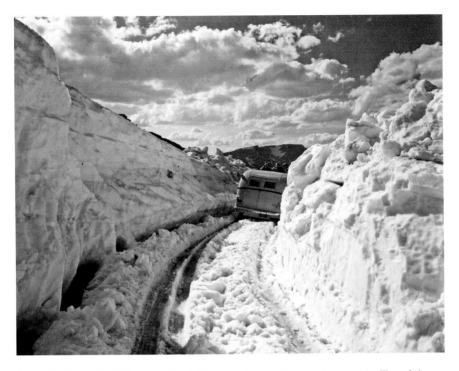

Snow didn't stop the Yellowstone Park Company from taking tourists over the Top of the World in its famous yellow buses. *Carbon County Historical Society.*

Another problem was signage and law enforcement. Many businesses in Red Lodge and Cooke City installed billboards next to the highway within the national forest boundaries—a violation of federal law. In addition to the billboards, "peddlers and itinerant salesmen" set up impromptu stands next to the highway to sell postcards and souvenirs to passing tourists. While federal law prohibited that activity, the forest service had no way to enforce the regulations. The lack of police presence on the highway compounded the problem. Wyoming steadfastly refused to send its highway patrolmen on the route. The Montana Highway Patrol cruised the entire length of the highway between Red Lodge and Cooke City three times a week, but it had no jurisdiction on federal land or within the state of Wyoming. The lack of law enforcement on the Beartooth was a chronic problem for the National Park Service and the forest service.

Of course, all the problems went virtually unnoticed by the thousands of tourists who traveled over the "new highway that thrills your heart" each summer. By 1939, the average daily traffic count was four hundred vehicles in July and August. During holidays and weekends, the number soared to

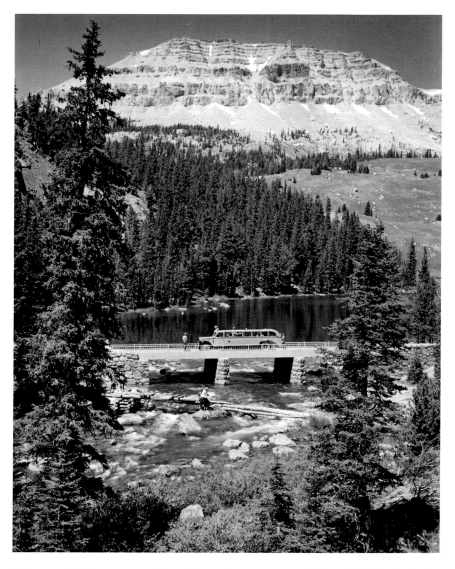

Yellowstone Park buses stopped along the road were a common sight on the highway during the summer months. *Carbon County Historical Society.*

one or two thousand vehicles as area residents flocked to the mountains to enjoy the cooler temperatures and recreational and sightseeing opportunities offered by the road. In 1941, there were several national forest campgrounds and picnic areas within a few miles of the highway.

New businesses in Red Lodge flourished, most catering to the thousands of tourists and Sunday drivers passing through the city. The number of

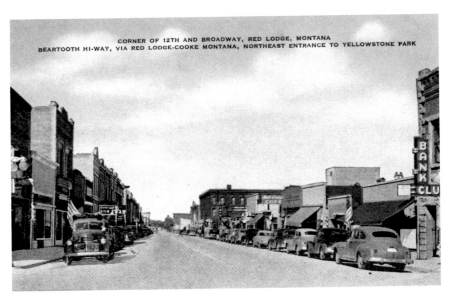

Downtown Red Lodge benefitted mightily by the presence of the highway, as this postcard image suggests. *Author's collection.*

Crosser's Super Service and Auto Court was one of many businesses in Red Lodge that catered to tourists on the Beartooth Highway. *Author's collection.*

motels in Red Lodge grew and included Harley's Cabins, Crosser's Super Service and Auto Court and a city-operated tourist park on the south end of town. Service stations, souvenir shops, drive-ins and restaurants prospered in Red Lodge. The Red Lodge Café and its famed neon dancing Indians sign opened in 1945. Another important roadside attraction was the See 'Em Alive Zoo, the only zoo in Montana when it opened in the early 1930s. Stocked primarily with animals captured in the surrounding area, such as bison, elk, deer, porcupines, rattlesnakes and bears, it also displayed more exotic animals like monkeys and camels. The zoo grounds exhibited handmade cobblestone monuments, fountains and other trappings; the visitors' center was a rustic log cabin adjacent to a trout pond.

The Beartooth Highway was a hit with tourists and local residents alike, but the chronic problem of maintaining it persisted. The dilemma was compounded after the United States entered World War II in December 1941. With the start of the "war emergency," funding dried up for non-strategic highways, like the Beartooth. There were no maintenance funds for the route beginning in 1942. There weren't any tourists anyway—gasoline and rubber rationing abruptly ended the golden age of automobile tourism. The NPS conducted some basic maintenance in 1942, but it was just enough to deplete its road budget from before the war.

By 1943, many area businessmen and federal officials became concerned that the country's $2 million investment in the Beartooth Highway was being wasted. There wasn't any money for maintenance, but apparently, few realized that fact. In July 1945, Dude Ranchers Association president Walter Nye wrote, "To most people it seems just darn poor business to spend several millions on that road and then just leave it to its fate." A few federal and Montana officials were also concerned about what condition the highway would be in when the war ended. The NPS began to almost desperately urge the Montana State Highway Commission to take over maintenance of the highway between Red Lodge and the Wyoming state line.[27]

No doubt, the National Park Service's inability to respond to the public's demands and the bureaucracy involved caused some heartburn for both groups. The Montana State Highway Commission seemed always on the brink of taking over maintenance of the Montana section of the highway but was frustrated by the federal red tape.[28] In July 1945, acting Montana governor Ernest T. Eaton wrote to NPS director Newton Drury:

Each year we have the same trouble it seems. The State Highway systems stand ready to help with men, materials, and equipment, but a request must

come from the Bureau of Public Roads before this aid will be available. The Bureau of Public Roads seems anxious to cooperate, but they say that nothing can be done until the superintendent of the Park requests assistance, and he in return says he is powerless unless directions come from the National Park Service.

At one point, the Red Lodge Chamber of Commerce offered to pay for snow removal, and it appears the Montana Highway Department did clear snow from the fifteen-mile Montana section in 1945.

The park service's push to get the highway department to take over maintenance of part of the Beartooth Highway gained momentum after the war. In September 1948, highway department maintenance engineer Ray Percy and representatives from the NPS toured the Beartooth Highway as part of the negotiation process. Prior to that, in March 1947, the Montana legislature, under Senate Bill 97, authorized the highway commission to "enter into cooperative agreements with the National Park Service and the Public Roads Administration for the purpose of maintaining national park approach roads in Montana."[29] The highway department's attitude was that it was responsible only for maintenance to the northern boundary of Segment C, and unless the federal government made a specific appropriation to the department to take over the road, it would go no further. Percy's fact-finding tour, however, indicates that the highway commission may have been leaning toward assimilating the Montana side of the Beartooth Highway.

In October 1948, Percy reported to the highway commissioners that the Beartooth Highway was in bad shape. Congress had allocated only $500 per year for the NPS to plow and maintain the road. Percy, rightfully, felt that it was not enough money. During the tour, he noted that most of the highway's guardrails needed to be replaced after being damaged by the U.S. Vanadium Corporation in 1942, when it mined chromite, a strategic mineral, on the Beartooth Plateau. Bridges needed repairs, a culvert needed to be replaced and most of the fifteen miles needed to be resurfaced. The highway commission's decision, based on Percy's recommendation, was that it would not assume maintenance of the section unless the park service made the necessary repairs to get the highway back into shape.

Percy also suggested that the federal government would need to allocate money to the highway department specifically for the maintenance of the Montana section. The money would be used to build storage sheds for maintenance equipment, install a communications system (the NPS had only one radio for plow drivers, and reception was spotty) and assign a

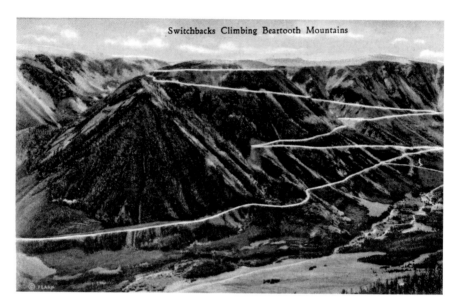

Switchbacks Climbing Beartooth Mountains

Many of the early postcards of the highway emphasized the switchbacks rather than the picturesque Wyoming side of the Beartooth. *Author's collection.*

power shovel, trucks and other heavy equipment for the exclusive use in the section. The total cost to the government, Percy estimated, would be between $25,000 and $30,000.

Despite several years of back-and-forth negotiations, both the NPS and the highway commission had dropped the maintenance matter by the early 1950s, and it was not resurrected again until 1960. In 1955, the House Committee on Appropriations stated in its report on the Department of the Interior's appropriation bill that although the NPS had been maintaining roads outside national park boundaries for years, it had no business doing so since it benefitted only businesses in those areas and not the park service. The committee disallowed a $100,000 request by the park service to improve park approach roads, including the Beartooth Highway. The NPS countered that it was trying to make arrangements with state highway departments to take over maintenance of the approach roads, but the process would take time. The future of the Beartooth Highway was in doubt.

After World War II, the Beartooth Highway remained a popular tourist attraction for people from all over the United States and the world. Its breathtaking scenery, numerous camera opportunities and the access it provided to recreationalists was, to some, overwhelming. Promotional brochures touted it as the "Top of the World," and the highway was featured

The Beartooth Highway has been a magnet for photographers since the 1930s. The photo from this shoot was a popular postcard. *Carbon County Historical Society.*

prominently in the Montana Highway Department's advertising films and publications during the 1950s. On June 1947, a freak weekend blizzard struck the highway, stranding around seventy motorists, some in fifteen-foot drifts caused by sixty- to seventy-mile-per-hour winds. Tragically, three National Park Service employees who attempted to rescue stranded travelers were themselves buried in a snowdrift and died. Most of the trapped motorists were rescued after twenty-four hours, with at least three requiring hospitalization in Yellowstone Park. The park service reopened the road after a couple of days, but the incident reminded everybody that Mother Nature could strike at any time, even in such a scenically stupendous area.[30]

By 1960, talk had once again begun between the park service and the Montana State Highway Commission about the maintenance of the Montana section of the Beartooth Highway. Wyoming still wanted no part in taking over its section of the highway. In a memorandum to state highway engineer Fred Quinnell Jr., Montana Highway Department administrative

engineer Albert Greiner stated that if the highway department assumed maintenance of the road, it would cost about $40,000 per mile to adequately take care of it (including snow removal). Greiner stated that some changes were needed to the alignment of the highway, the existing grade was deteriorating and it needed to be resurfaced. But he felt it could be done with BPR Federal Land funds that would be allocated specifically to the Montana Highway Department for the work. He concluded that the basic problem over jurisdiction was based on the highway's origin as a Great Depression make-work project, not as an important link in the development of a nationwide transportation system.

Greiner's memorandum seems to have been the spark that caused the highway commission to reconsider assuming some responsibility for the road. Indeed, in 1964, the National Park Service turned over maintenance of the Montana section of the highway to the Montana Highway Department. Construction activities, however, remained the province of the Bureau of Public Roads (the Federal Highways Administration after 1966). In 1964, the BPR began a three-phase project to reconstruct and improve the highway from Richel Lodge to the Wyoming line. The first phase, in 1964, improved 8.7 miles of the highway from the base of the switchback section to the state line. The project included the construction of the Rock Creek Vista Point at Milepost 40. In 1965, the BPR awarded a contract to the Sheridan, Wyoming–based Hussman Brothers Company to rebuild 4.3 miles of the highway from Richel Lodge to the base of the switchback section. The bureau also awarded money to reconstruct the Wyoming section of the highway in the late 1960s. Throughout this period, though, the NPS and the Montana Highway Department collaborated to plow the snow off the road in the spring of each year, with a target date for opening the route during the Memorial Day weekend.

In the 1990s, the Montana Department of Transportation (MDT) assumed responsibility for construction activities on the highway. In the early 1990s, the MDT repaved and installed new guardrails on the Montana section of the highway. Earth slides in May 2005 destroyed a dozen places between mileposts 39 and 51 and closed the road for much of the season. By utilizing innovative new construction methods, the project was completed ahead of schedule. The efforts made by both federal and state agencies since 1960 are clear indications of the significance of the Beartooth Highway.

News correspondent Charles Kuralt famously described the Beartooth as "the most beautiful drive in America." It seems the appellations heaped on the Beartooth Highway are as diverse as the scenery that can be viewed

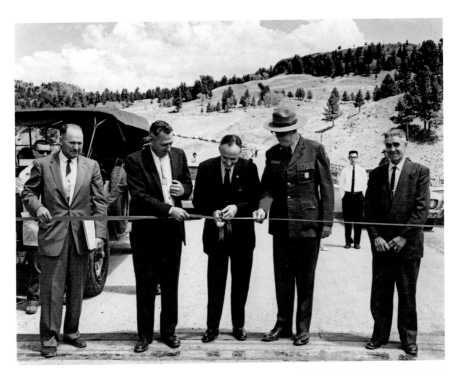

Above: During the 1960s, the BPR and Montana Highway Department reconstructed the highway. Montana senator Mike Mansfield (center) helped obtain funding for the projects. *Carbon County Historical Society.*

Right: Communing with nature on the Beartooth Highway is just as important as driving the route. Many take advantage of opportunities for taking a closer look at the scenery. *Carbon County Historical Society.*

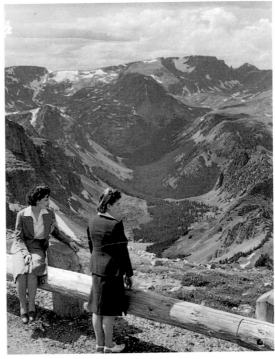

from the road, a road with a history "perched jauntily on canyon walls and the brink of some of nature's most awesome precipices." But maintaining that road and all its magnificence has been a challenge requiring great expenditures of taxpayers' money to keep open. While some may debate the presence of the road and the impact its has on the environment, public support has been overwhelmingly in support of keeping it open for the benefit of all Americans. The debate over maintenance has not been generally known to most people, but they certainly appreciate the efforts of those who remove the snow, repair the guardrails, patch the potholes and resurface the highway.

8

THE ALL-AMERICAN ROAD AND THE REBIRTH OF RED LODGE AND COOKE CITY

Once a year, the Red Lodge Chamber of Commerce selects a snowbank beside the road, carves out an icy counter, stocks it with beverages, and serves all who pass from its "Top of the World Bar." The date is secret, but the event has become an annual celebration.
—*Muriel Sibell Wolle, 1962*

Although Charles Kuralt's observation of the Beartooth Highway as "the most beautiful drive in America" is the most quoted in regards to the scenic byway, there are countless descriptions of the route written by others who have experienced the drive. What is obvious and consistent in most of the passages is that the road was designed for tourists. What the accounts often contain, though, are references to how the route's appeal and significance have had an impact on Red Lodge, Cooke City and the surrounding area. Prior to the completion of the highway in 1936, Red Lodge was an end-of-the-road coal mining camp with a rich history and residents from throughout the United States and Europe. As the mines began to shut down in the 1920s, the community desperately sought ways to rebrand itself in order to survive. In this case, Red Lodge transformed itself from a coal mining camp into a resort/tourist community, yet it has retained the flavor of both phases of its colorful history. The successful makeover created a hybrid community that is unique in Montana and a much sought-after destination point for local, national and international visitors.

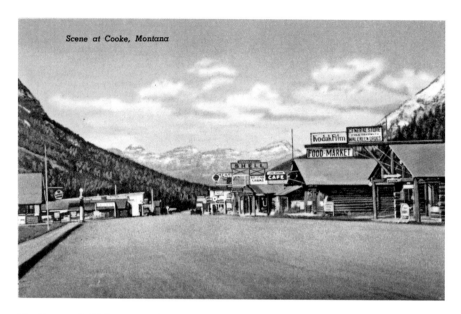

Scene at Cooke, Montana

The Beartooth Highway transformed Cooke City from an isolated mining camp into an important tourist stop near the northeast entrance to Yellowstone Park. *Author's collection.*

Likewise, Cooke City also made the transformation from mining camp to resort and tourist stop. Although some mining continued in the mountains northeast of the village, it prospered more as a recreational destination and a colorful wide spot in the road for thousands of tourists who pass through it every year. By the 1950s, Cooke City's main street was populated by restaurants, souvenir shops and motels, all catering to the thousands of tourists who passed through the community each summer. Like Red Lodge, Cooke City has also maintained its rustic flavor and has never denied its origins as a mining camp.

When the Beartooth Highway was under construction in 1935, entrepreneurs John Taylor and J.J. White formed the Silver Gate Company to establish a tourist-oriented community on the highway at the northeast entrance to Yellowstone Park. Named for nearby Silver Mountain and the proximity to the park, Silver Gate's original building codes specified rustic, frontier-type architecture consisting of log businesses and residences. The community boasted only thirty year-round residences, but it was enough to warrant the opening of a post office in 1937. In 1939, the Federal Writers' Project described Silver Gate as a "summer hamlet of stores, amusement centers, tourist cabins, hotels, and gas stations, all catering to tourists."[31]

Harley Weydt opened a tourist cabin camp on South Broadway Avenue in Red Lodge shortly after the Beartooth Highway officially opened in 1936. *Author's collection.*

Even before the highway officially opened in 1936, Red Lodge sought to capitalize on the new road. Local businessmen and entrepreneurs made plans to build motels, gas stations, restaurants and other facilities to provide services to hordes of tourists expected to pass through town. By 1940, at least two motels and a tourist cabin camp supplemented the city's older hotels. Most of the new motels were located on South Broadway Avenue, south of the city's business district. Two of the better-known roadside inns were Harley's Cottages and Crosser's Super Service & Auto Court. The city-owned Red Lodge tourist park consisted of small single and double log cabins located just off the city's main thoroughfare. All reflected the popular cottage camp craze sweeping the nation in the years preceding World War II. Founded by Harley Weydt, the Harley's Cabins later added a service station to better compete with Crosser's operation. After Crosser's closed, Harley's continued to operate, under different names, as a motel until the 1990s. The Red Lodge tourist park was known as Red Lodge Court Cabins after the war and today still caters to tourists and others wanting to experience a unique vintage motel experience.

Other motels opened in Red Lodge following World War II and the initiation of the second great period of automobile tourism in the United States. Instead of being located only south of town, however,

The neon Red Lodge Café sign has been a city landmark since 1948. *Photo by Carroll Van West, montanahistoriclandscape.com.*

the motels were located on Broadway Avenue north and south of the business district. Many still operate as motels. The most notable of these is the Yodeler, a converted apartment house built for coal miners about 1910. Red Lodge contractor Al Sloulin transformed the building into its current Swiss chalet appearance in the early 1960s. The Swiss Alps–themed motel was the first to take advantage of the city's mountainous setting, the opening of nearby Red Lodge Mountain ski resort in 1960 and its proximity to the Beartooth Highway.

Along with the motels, there were also many service stations, restaurants (including a few drive-ins), grocery stores, souvenir shops and other businesses that catered specifically to tourists during the summertime. The most well-known restaurant in the city is the Red Lodge Café. The eatery opened at its current location in 1930 and operated as the Burton Café until 1945, when Margaret Buening purchased the business and gave it its current name. It was under Buening's ownership that the iconic dancing Indians neon sign was installed in 1948.

Roadside attractions also characterized the Beartooth Highway beginning in the 1930s. The famed See 'Em Alive Zoo opened its doors for tourists about 1932 and "quite literally brought the wild into Red Lodge."[32] The zoo

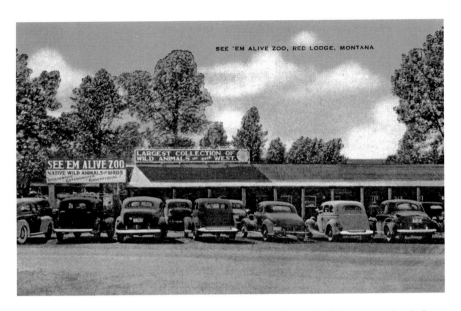

From about 1932 until the late 1970s, the See 'Em Alive Zoo in Red Lodge was the city's premier roadside attraction. *Author's collection.*

originated as a fox farm owned by Beartooth Highway promoter Dominic Columbus and Les Lyons. With construction on the highway nearing completion, the partners retooled their business as a roadside attraction that became the town's biggest tourist draw. The zoo, the only one in Montana at the time, owed its success to the highway. Most of the animals in the zoo were native to the area and included bison, deer, elk, moose and bears. Smaller animals also sparked the interest of visitors. These included fox, bobcats, marmots, porcupines and rattlesnakes (in a heated enclosure). Visitors entered the zoo through a rustic log building (which still stands across from the junction of Secondary Highway 308) and passed by a well-stocked trout pond on their way into the zoo. The grounds displayed a number of cobblestone structures and other constructs. The cages, however, were small and not particularly beneficial to the health of the animals they held. The See 'Em Alive Zoo was a staple of the Red Lodge economy until it closed down in the late 1970s.[33]

One of the most popular attractions associated with the highway was not located in Red Lodge but near the top of Beartooth Pass on the highway. Once every year, on an unannounced date sometime in July from 1946 until the early 1970s, the Red Lodge Chamber of Commerce opened a bar (called a buffet in the newspapers) near the halfway point on

The Red Lodge Chamber of Commerce opened the Top of the World Buffet one day each summer. Its members served as bartenders at this unique roadside attraction. *Flash's Photography.*

The sixty-eight-mile Beartooth Highway makes the best use of the wild terrain to provide an unforgettable traveling experience for millions of motorists. *Carbon County Historical Society.*

the highway. Originally called "Nature's Own Bar," it was popularly known as the Top of the World Buffet by 1954. Red Lodge Chamber members Harley Weydt and Roy Donelson conceived of the idea of the bar after serving drinks to outdoor writers on top of the plateau.[34]

Built "for action and not for looks," the thirty-foot bar carved out of a snowbank served beer, cocktails, soft drinks and hot coffee to motorists who stopped there after being hailed by the men. Weydt told a *Billings Gazette* reporter in 1954 that at first "people were amazed, but not frightened by the attraction. ...In previous years, some tourists fearing a trap, refused to stop when hailed by the greeters." Open only one day a year, the bar served up to one thousand people between its operating hours of 11:00 a.m. to 5:00 p.m. The Top of the World Buffet remained a popular attraction for motorists on the Beartooth Highway until the early 1970s, when attitudes about alcohol and driving changed.[35]

Recreation opportunities abounded in the mountains between Red Lodge and Cooke City after the highway officially opened in 1936. The Forest Service opened several campgrounds and picnic areas that were easily accessed by the Beartooth Highway. Fishing and hiking became important draws for tourists, along with an increase in the number of dude ranches in the vicinity of the highway. Many residents of south-

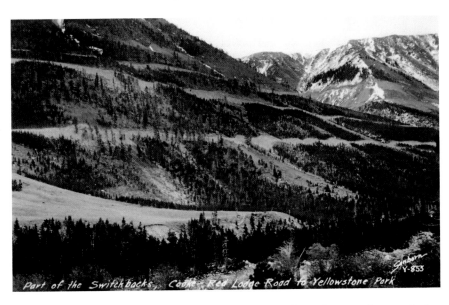

The switchbacks up the side of Rock Creek Canyon are, perhaps, the most photographed feature of the highway. *MHS Photograph Archives, Helena, 957-853.*

central Montana and north-central Wyoming took day trips over the highway in the summer to escape the heat in the high altitude of the Beartooths. For a time, itinerant hawkers sold maps and other souvenirs in temporary stands built illegally next to the highway. Park service employees and Montana highway patrolmen often had to close them down and tell them to move along. At first, the peddlers were almost as distracting as the scenery along the highway.

THE PRINCETON GEOLOGY FIELD CAMP

In addition to his medical practice and his promotion of Carbon County, J.C.F. Siegfriedt was a passionate amateur geologist. Even before President Hoover signed the legislation that resulted in the construction of the highway, Princeton University's Geology Department began conducting annual field camps in the Beartooth Mountains south of Red Lodge. Called initially the Red Lodge Project by Professor Taylor Thom and Richard Field, students spent several weeks each summer studying the geology of the Beartooths. Housed originally at Siegfriedt's Piney Dell resort (which would also be the site of contractor staging areas when the highway was under construction), the camp was also based at the nearby Camp Senia dude ranch for a few summers before the school's permanent camp was established on Mount Maurice in 1936. The newly formed Yellowstone Bighorn Research Association (YBRA) celebrated the opening of the new camp with a pig roast for Red Lodge's citizens. In 1942, the Princeton Geology Association, which owned the campsite, sold it to the YBRA for one dollar.

The establishment of the permanent camp coincided with the official opening of the Beartooth Highway. Undoubtedly, the highway gave greater access to the field school's students than it had before its completion. Since 1936, the field school has been the base for university and college students from throughout the United States. It also has been the site of conferences by the venerable American Geological Institute, the International Geological Congress and the Billings and Montana geological societies. It has also hosted summer institutes for teachers and field schools for non-geologists and others interested in geology and natural history.

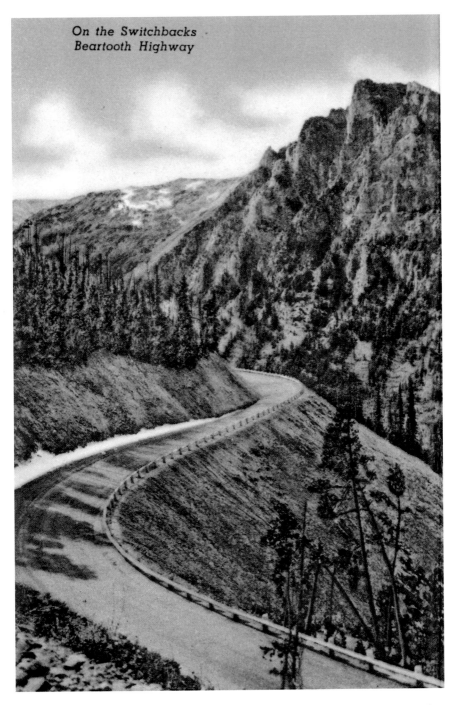

On the Switchbacks
Beartooth Highway

Professional photographers took more pictures of the Beartooth than of any other route in the state, often selling them at roadside stands. *Author's collection.*

The Beartooth Highway also exceeded the expectations of the National Park Service. Traffic counters noted a steady climb in the number of vehicles entering the park west of Cooke City during the summer months, with that number doubling during the weekends and on holidays. In 1937, 55,000 vehicles per summer season crossed over the mountains; by 1946, that number had risen to 66,000 vehicles per year. In 2015, the average daily traffic number was 480 vehicles per day when the road was open.

Red Lodge, like Cooke City, relies heavily on the Beartooth Highway for its economic prosperity. Historian Bonnie Christensen has stated that "Red Lodge residents immediately took a possessive pride in their highway and even before it was officially opened the road became a prominent marker in the town's public identity."[36] The city transformed itself into a unique combination of mining camp and resort community. Red Lodge business owners look forward to the opening of the highway each spring, and delays in opening can cause significant economic hardships for some of them. The closure of the highway in 2005 had a significant impact on the community, as does the continuing debate about maintenance of the highway on the Wyoming side of the border

The Beartooth Highway continues to amaze and inspire awe in travelers as much as it did in the 1930s. The glowing descriptions of the road beginning in the 1930s don't do the highway justice. At least some of the wonder the highway generates among motorists, perhaps, is the effort it took to build it. It was a successful collaboration between three federal agencies to provide a facility that was, and is, unmatched in the lower forty-eight states. Some might ask if the road could be constructed today with the abundance of environmental laws that were not in existence in the 1930s. That's a good question, and the answer is probably not. But despite that, the Beartooth Highway opens a window in the spectacular scenic and natural environment of an alpine ecosystem that might not otherwise be available to most Americans. The Beartooth Highway is also a story of man versus nature in its construction. It was no easy task, and the men who built it early on recognized the importance of their contribution to it. Fortunately, the names the builders gave to the features along the road still exist, but few probably know who curvy 1930s movie star Mae West was. The highway is significant on many different levels, and that importance was recognized in 2014, when the National Park Service listed it in the National Register of Historic Places, one of only a handful of highways in the American West to win that designation.

NOTES

M uch of the information utilized for this book was acquired from the Yellowstone National Park Archives in Gardiner, Montana. The material was gathered and photocopied by Historical Research Associates, Inc. of Missoula, Montana, for a National Register of Historic Places nomination the company prepared under contract to Yellowstone National Park in the early 2000s. The photocopied documents are now housed at the Carbon County Historical Society in Red Lodge, Montana.

CHAPTER 1

1. *(Red Lodge, MT) Carbon County News*, "Red Lodge-Cooke City Road Attracts Throngs as News of Opening Spreads," June 16, 1936.
2. *(Red Lodge, MT) Picket-Journal*, "Rodeo Visitors Told of New Park Highway," July 6, 1933.

CHAPTER 2

3. Moulton, *Definitive Journals*, 187.
4. Sheridan, *Report of Sheridan*, 7.
5. Ibid., 8, 18.

CHAPTER 3

6. *Billings (MT) Gazette*, "First Leg of New Trail to be Ready Soon," August 1, 1919.

CHAPTER 4

7. By 1926, U.S. Highway 2 across northern Montana remained unfinished. There was a sixty-mile gap in the road from East Glacier around the southern tip of Glacier National Park to West Glacier (then called Belton). Travelers wishing to reach either of the two communities had to load their automobiles on Great Northern Railway flatcars, which ferried them to the other side. It was not until 1930 that U.S. 2 was completed across Montana from the North Dakota border to Idaho.
8. *(Red Lodge, MT) Carbon County News*, "Large Delegation Motors to Billings to Meet the Beartooth Boosters' Representative from Washington," May 13, 1926; *Billings (MT) Gazette*, "Beartooth Boosters Learn at Shelley Reception Here Cooke City Road Is Assured," May 13, 1926.
9. *(Red Lodge, MT) Carbon County News*, "Congressman Leavitt Views Route of Proposed Red Lodge-Cooke City Road and Is Favorably Impressed," August 26, 1926.
10. Ibid., "Well Deserved Praise," October 27, 1927; "Scenic Cooke City Road Survey Is Started," May 26, 1927.
11. Ibid.
12. Smith et al., Historic District National Register of Historic Places Registration Form (hereafter cited as National Register Nomination).

CHAPTER 5

13. The design standards for the highway underwent an evolution of design changes between 1931 and 1936. The standards originally called for a fourteen-foot-wide roadway but were later changed to sixteen feet and then finally completed at twenty-two feet. The BPR replaced the crushed gravel surface with a bituminous pavement beginning in 1935.
14. *(Red Lodge, MT) Picket-Journal*, "Red Lodge Prosperity Is Widely Recognized," March 5, 1931; "Cooke Road Now Up to Secretary Wilbur," February 5, 1931.

15. Ibid., "Cooke Road Bidders Look Over Unites Up for Contract," June 25, 1931.

16. National Register Nomination.

17. Edwards et al., Final Report, 1–151; *(Red Lodge, MT) Picket-Journal*, "Move Equipment to Hell Roaring Camp," September 17, 1931; *(Red Lodge, MT) Carbon County News*, "Memories of Building the 'High Road,'" June 19, 1986.

18. *(Red Lodge, MT) Carbon County News*, "Red Lodge People See Beginning of Construction on Park Road," September 10, 1931.

19. National Register Nomination.

20. Edwards et al., Final Report, 1932.

21. *(Red Lodge, MT) Picket-Journal*, "First Motor Traffic to Cooke City Disdains Unfinished Highway," July 27, 1933.

22. *(Red Lodge, MT) Picket-Journal*, "Trade Magazine Gives Local Highway Praise," July 26, 1934.

23. In addition to Glen Welch's death on Segment B in September 1933, Red Lodge resident Waino Timonen died when he fell into gravel-crushing machinery in October 1933.

24. *Helena (MT) Independent-Record*, "Red Lodge-Cooke City Road Attracting Tourist Throng," June 23, 1936.

CHAPTER 6

25. Mitchell, Final Construction Report, 1–18.

CHAPTER 7

26. It wasn't until after World War II that the Wyoming Highway Commission built Secondary Highway 296, the Chief Joseph Scenic Highway, to connect Cody, Wyoming, to the Beartooth Highway. Still, that road is also often blocked by snow during the winter months.

27. National Register of Historic Places Nomination.

28. The "Montana section" involved the fifteen miles between Red Lodge and the Wyoming state line. There was, however, the nine-mile segment between the northeast entrance to Yellowstone Park through Cooke City to the Wyoming line on the north. Perhaps pragmatically, both the NPS and the Montana Highway Department realized that the NPS

would always be responsible for snow removal on that segment because of its isolation.

29. *Laws, Resolutions and Memorials of the State of Montana Passed by the Thirtieth Legislative Assembly in Regular Session* (Helena, MT: State Publishing Company, 1947), 505.

30. *Helena (MT) Independent-Record*, "Three Die in Blizzard on Cooke City Highway," June 22, 1947.

CHAPTER 8

31. Federal Writers' Project, *Montana*, 348.

32. Christensen, *Red Lodge*, 396; Zupan and Owens, *Red Lodge*, 62–63.

33. The author remembers well visiting the zoo in the 1960s and early 1970s. It was a wondrous place, at first, where visitors were encouraged to feed the animals. Unfortunately, the small population of ducks at the zoo eventually grew into a large flock of hungry ducks that mobbed visitors for their popcorn. By the 1970s, the zoo was clearly in decline, and the author, who once loved the zoo, became concerned about the welfare of the animals, including some species that were not native to Montana (monkeys, llamas, a camel and a lion cub).

34. *Billings (MT) Gazette*, "The Top of the World Bar Is Busy," July 25, 1954.

35. Ibid.; Jim Berry, "Beer in the Snow," *Billings (MT) Gazette*, July 22, 1971.

36. Christensen, *Red Lodge*, 188–89.

BIBLIOGRAPHY

BOOKS, MAGAZINES AND REPORTS

Aaberg, Stephen A. Cultural Resource Survey along U.S. Highway 212 from the Wyoming Border to Milepost 60, Carbon County, Montana. Report prepared for the Montana Department of Transportation by Aaberg Cultural Resource Consulting Service, January 1993.

Axline, Jon. "Doc Siegfriedt and the Black and White Trail." *Newsline: Newsletter of the Montana Department of Transportation Rail, Transit & Planning Division* (September 2011): 7.

———. "The Greatest Piece of Road in America: The Beartooth Highway." *Montana Historian* (2016).

———. *Taming Big Sky Country: The History of Montana Transportation from Trails to Interstates.* Charleston, SC: The History Press, 2015.

Blevins, Bruce H. *Beartooth Highway Experiences.* Powell, WY: WIM Marketing, 2003.

Brooke, William M. "A Contest Over Land: Nineteenth-Century Crow-White Relations." In *Montana Vistas: Selected Historical Essays*, edited by Robert R. Swartout Jr. Lanham, MD: University Press of America, 1981.

Burlingame, Merrill G. *The Montana Frontier*. Helena, MT: State Publishing Company, 1942.

Christensen, Bonnie. *Red Lodge and the Mythic West: Coal Miners to Cowboys*. Lawrence: University of Kansas Press, 2002.

Coleman, Melvin D. *The Beartooth Highway: The Most Beautiful Road in America*. Billings, MT: Artcraft Printers, 1986.

Federal Highway Administration. *American Highways, 1776–1976*. Washington, D.C.: Government Printing Office, 1976.

Federal Writers' Project. *Montana: A State Guide Book*. Helena, MT: Department of Agriculture, Labor and Industry, 1939.

Glidden, Ralph. *Exploring the Yellowstone High Country: A History of the Cooke City Area*. 2nd ed. Cooke City, MT: Cooke City Store, 1982.

James, H.L. *Geologic and Historic Guide to the Beartooth Highway, Montana and Wyoming*. Special Publication 110. Butte: Montana Bureau of Mines and Geology, 1995.

Lampi, Leona. "From a Frenetic Past of Crows, Coal and Boom and Bust Emerges a Unique Festival of Diverse Nationality Groups." *Montana the Magazine of Western History* 11, no. 3 (Summer 1961).

Leeson, M.A. *History of Montana, 1739–1885*. Chicago: Warner, Beers & Company, 1885.

Malone, Michael P., Richard B. Roeder and William L. Lang. *Montana: A History of Two Centuries*. Rev. ed. Seattle: University of Washington Press, 1992.

Montana Place Names from Alzada to Zortman: A Montana Historical Society Guide. Helena: Montana Historical Society Press, 2009.

Moulton, Gary E., ed. *The Definitive Journals of Lewis & Clark: Over the Rockies to St. Louis*. Vol. 8. Lincoln: University of Nebraska Press, 2002.

Murray, Ester Johansson. "Dr. Siegfriedt and the Black and White Trail." Unpublished paper on file at the Carbon County Historical Society, Red Lodge, Montana.

———. *The Red Lodge-Meeteetse Trail.* Red Lodge, MT: self-published, 1985.

Sheridan, Philip Henry. *Report of Lieutenant General P.H. Sheridan dated September 20, 1881 of His Expedition through the Big Horn Mountains, Yellowstone Park, etc.* Washington, D.C.: Government Printing Office, 1882.

Smith, Ian, Elaine Skinner Hale et al. Red Lodge–Cooke City Approach Road Historic District National Register of Historic Places Registration Form. NR Reference #14000219. Nomination prepared by Historical Research Associates, Inc.; Yellowstone National Park, Missoula, Montana; and Yellowstone National Park, Wyoming, May 2014.

Spritzer, Don. *Roadside History of Montana.* Missoula, MT: Mountain Press Publishing Company, 1999.

Taylor, Bill, and Jan Taylor. *The Northern Pacific's Rails to Gold and Silver: Lines to Montana's Mining Camps.* Vol. 2. Missoula, MT: Pictorial Histories Co., Inc., 2008.

Zupan, Shirley, and Harry J. Owens. *Red Lodge: Saga of a Western Area.* Billings, MT: Frontier Press, Inc., 1979.

NEWSPAPERS

Billings (MT) Gazette

(Red Lodge, MT) Carbon County News

(Red Lodge, MT) Picket-Journal

BIBLIOGRAPHY

ARCHIVAL COLLECTIONS

Carbon County Historical Society, Red Lodge, Montana.

Central Federal Lands Highway Division, Denver, Colorado.

Montana Department of Transportation, Helena, Montana.

Montana Historical Society. Research Center, Helena, Montana.

Western Federal Lands Highway Division, Vancouver, Washington.

Yellowstone National Park Archives, National Archives and Records Administration, Gardiner, Montana.

Yellowstone National Park Library, Gardiner, Montana.

INDEX

A

Albright, Horace 43, 49–50, 66, 71
Anaconda Copper Mining
 Company 29, 31
Arapooish 28

B

Bear Creek 31, 40
Bearcreek (city) 31, 33–36, 56, 61
Beartooth Boosters' Club 44, 46
Beartooth National Forest 36, 56
Billings Chamber of Commerce 45
Billings Gazette 18, 71, 105
Black and White Trail 19, 33–37,
 39, 40
Black and White Trail Association
 33, 35
Buening, Margaret 102
Burton Café 102

C

Campbell, Will 41
Carbon County News 18, 20, 41–42,
 45–47, 66, 71
Carlson, Albert 35
Chicago, Burlington & Quincy
 Railroad 37
Clark, William 26
Columbus, Dominic 102
Coverdale, John 68
Crosser's Super Service & Auto
 Court 101
Crow Indians/Reservation 28
Curran, Dan 35
Custer National Forest 59

D

Donelson, Roy 105
Dowell, Cassius 44
Drury, Newton 92
Dude Ranchers Association 92

E

Eaton, Ernest T. 92
Edwards, Guy 59, 80
Emergency Construction Act of
 1930 52

F

Federal Aid Road Act of 1916 35
Federal Aid Road Act of 1921 36, 51
Federal Highway Administration 16
Federal Writers' Project 100
Ferguson, R.T. 36, 56
Fort Laramie Treaty of 1851 28
Fort Laramie Treaty of 1868 28
Fort Washakie 30

G

Gardiner, Montana 21, 31, 40,
 57–58, 77–79, 88
George, James "Yankee Jim" 28–29
gippos 77–78, 80
Going to the Sun Highway 13, 15, 86
Greiner, Albert 96

H

Harding, Warren G. 42
Harley's Cottages 101
Hemingway, Ernest 62
Hoover, Herbert 21, 39, 50, 52–53,
 55, 106
House Resolution (HR) 12404 49
Hussman Brothers 96

J

Jeffery, George 44

K

Keil, George 88
Kuralt, Charles 23, 96, 99

L

Leavitt Bill 49
Leavitt, Scott 20, 41, 43–45, 49, 55
Line Creek 12, 19, 35–36, 71, 73
Lyons, Les 102

M

Mae West Curve 65–66
McKinnon, Eugene 71
McLaughlin, J.L. 70, 72, 84
McNutt, Jack 76–81
McNutt & Pyle 57–59, 62, 65–66,
 68–69, 75–82
Meteetsee Trail 29–30
Mitchell, Harry E. 46–48, 53, 56,
 58, 71, 75, 77–80
M-K Campground 59
Montana Department of
 Transportation 12, 23, 96
Montana Highway Department 21,
 25, 93, 95–96, 97
Montana Highway Patrol 89, 106
Montana State Highway
 Commission 18–19, 35–36,
 44, 55, 68, 84, 86, 92, 95
Morrison-Knudsen Construction
 Company 56, 58–69, 75, 77,
 80, 82
Mount Maurice 35–37, 39, 106

N

National Park Approaches Act of
 1931 39, 46, 50, 51–52, 55
National Register of Historic Places
 11, 23
New World Mining District 31,
 40, 43
Nordquist, Lawrence and Olive
 57, 61
Nordquist/L Bar T Ranch 58, 61, 78

Northern Hotel 45
Northern Pacific Railway 29–31, 45, 57–58, 70, 77
Nye, Walter 92

P

Percy, Ray 93–94
Piney Dell 61, 68, 106
Princeton Geology Field Camp 106
Pyle, Guy 75–77

Q

Quad Creek 56–57, 68
Quinnell, Fred, Jr. 95

R

Red Lodge Café 92, 102
Red Lodge Chamber of Commerce/Commercial Club 19, 86, 88, 93, 99, 103
Red Lodge Court Cabins 101
Red Lodge Mountain 102
Red Lodge Picket-Journal 35, 41, 63, 71–72
Red Lodge tourist park 92, 101
Richel Lodge 61–62, 96
Rock Creek Canyon 17, 55–57, 59, 63, 65, 81, 105
Rock Creek Vista Point 96
Rocky Fork Coal Company 18, 29–30
Rocky Fork & Cooke City Railway 29
Romney, Miles 41

S

See 'Em Alive Zoo 22, 92, 102–103
Shelley, O.H.P. 20, 41–45, 47, 49, 52, 55, 60, 61, 66, 71, 81, 84
Sheridan, General Phillip 18, 26–28

Shoshone National Forest 41
Siegfriedt, J.C.F. 20, 31–32, 33–37, 45, 60, 61, 68, 106
Silver Gate 18, 100
S.J. Groves & Sons 69–70, 82

T

Tanzer, Gottwerth "Doc" 31
Thatcher, T.O. "Red" 35–36
Toll, Roger 71
Top of the World Bar/Buffet 99, 103, 105

U

U.S. Vanadium Corporation 93

V

Vint, Thomas 66

W

Walsh, Thomas J. 44
Warden, Oliver S. 41
Washburn & Hall 80
Western Smelting and Power Company 31
West Side Mine 30
Weydt, Harley 101, 103, 105
Wheeler, Burton K. 44
Wilbur, Ray Lyman 53
Winston Brothers 68, 75, 82
Wyoming Highway Commission 86
Wyoming Highway Patrol 89

Y

Yodeler Motel 101

ABOUT THE AUTHOR

Jon Axline has been the historian at the Montana Department of Transportation since 1990. When not sweating over the state's historic roads and bridges, he conducts cultural resource surveys and writes the MDT's roadside historical and geological interpretive markers. Jon is a regular contributor to *Montana Magazine* and *Montana: The Magazine of Western History*. He is also the author of *Conveniences Sorely Needed: Montana's Historic Highway Bridges* and *Taming Big Sky Country: A History of Montana Transportation from Trails to Interstates* and editor of *Montana's Historical Highway Markers*. Jon lives in Helena with his wife and four Corgis.

Visit us at
www.historypress.net

···

This title is also available as an e-book